THE CORPORATE MEDIA TOOLKIT

The Corporate Media Toolkit offers corporate writers, producers and directors an accessibly-written, hands-on guide to practical techniques important in producing high-quality, nuanced work in a corporate environment. Exploring each phase of media development—project inception, client interactions, scriptwriting, preproduction, casting, auditions, production and postproduction—author Ray DiZazzo teaches readers how to "know what works" in corporate media, as well as an ability to focus on the nuance and subtleties that elevate typical media to a higher quality standard, whether it's crafting an intelligent script, framing and lighting a shot correctly, or knowing what transition to use in the editing suite.

The book also features case studies illustrating real-life scenarios from the author and other corporate professionals, demonstrating these crucial techniques in practice. The Corporate Media Toolkit is a must-read for professionals and newcomers alike to bring their corporate media skills to the next level.

Ray DiZazzo is the author of four other books on corporate media published by Focal Press, including Corporate Media Production (2003) and Directing Corporate Video (1993). He has also produced hundreds of corporate media projects and received numerous awards, including ITVA and Telly Awards.

THE CORPORATE MEDIA TOOLKIT

Advanced Techniques for Producers, Writers and Directors

Ray DiZazzo

Routledge
Taylor & Francis Group

NEW YORK AND LONDON

First published 2017
by Routledge
711 Third Avenue, New York, NY 10017

and by Routledge
2 Park Square, Milton Park, Abingdon, Oxon OX14 4RN

Routledge is an imprint of the Taylor & Francis Group, an informa business

Library of Congress Cataloging in Publication Data
Names: DiZazzo, Raymond, author.
Title: The corporate media toolkit : advanced techniques for
 producers, writers and directors / Ray DiZazzo.
Description: New York and London : Routledge, 2017. |
 Includes index.
Identifiers: LCCN 2017001575 (print) | LCCN
 2017019461 (ebook) | ISBN 9781315225722
 (E-book) | ISBN 9780415787789 (hardback) |
 ISBN 9780415787796 (pbk.)Subjects: LCSH: Video
 recordings—Production and direction. | Industrial
 television. | Industrial television—Authorship.
Classification: LCC PN1992.94 (ebook) | LCC PN1992.94.
 D575 2017 (print) | DDC 791.4502/32—dc23
LC record available at https://lccn.loc.gov/2017001575

ISBN: 978-0-415-78778-9 (hbk)
ISBN: 978-0-415-78779-6 (pbk)
ISBN: 978-1-315-22572-2 (ebk)

Typeset in Joanna MT Std
by Swales & Willis, Exeter, Devon, UK

For Ned Rodgers and Ralph Phillips both great writers,
directors and mentors.
With special thanks to Dick Jones for the break in 1980 and
Glenn Hunter for his generous support.

CONTENTS

INTRODUCTION

Einstein put it this way: $E = MC^2$.
We call it,"Action!"

$E = MC^2$. In layman's terms that equation means you can get a whole lot of energy out of a small amount of matter. Einstein was talking about *cosmic* matter, of course—the stuff of suns, galaxies, planets, atoms and all the other mysterious building blocks of our universe. In this book, we'll be talking about *brain* matter. Or, more specifically, the brains of corporate writers, producers and directors.

If we wanted to use Einstein's equation as an analogy "relative" to corporate media, we could put it this way:

E = the energy created by a writer, producer or director.

MC = the "matter" that goes on the pages of a script; the directions given to an actor on a corporate shoot; the decisions a producer makes to move forward with a client's project and commit the time and resources needed to make it a high-quality corporate program.

2 = the exponential power of the program generated by by $E = MC$. In other words, the power to change minds, beliefs and attitudes—the power to change lives!

Or, we could simplify by saying that the seemingly little things that go into the production of a corporate program can dramatically increase its quality level and thus the impact it will have on viewers.

Focusing on those little things is what this book is all about.

I've tried to explore each of the phases of the production process—writing, directing, producing and editing—by examining the more subtle techniques a writer, producer or director can put into practice to improve the quality of his work.[1] I've also included chapters on sensibilities—an important topic at the heart of this exploration—and client and producer handling.

You will find that this book is not quite as lengthy and weighty as many other books on the subject of corporate media, and, in fact, that it's relatively short. This is by design. I've left out a good deal of basic instructional material on the assumption that you have a working knowledge of how videos and films are written, produced and directed. If that's not the case, you should first gain that knowledge and return to this book in the future.

I hope you find this reading experience engaging, enjoyable and valuable, and I wish you the best of luck on your corporate media journey.

Ray DiZazzo

NOTE

1 Throughout this book references to 'he/his' are not intended to be gender-specific and can equally be read as 'she/her'.

1

A CUT ABOVE

It's all about the "little" things!

In This Chapter

B-Roll: A Subtle Difference
A Director's Command
The Power of Subtlety and Nuance

B-ROLL: A SUBTLE DIFFERENCE

Quite a few years ago, when I was working as a new director for a large company, I was given a challenging project that included a significant budget. It was a program on the subject of quality that was to be shown to thousands of employees. Since the development and production schedule were tight, while I concentrated on shooting the program host and primary material, I hired a videographer to travel to various company locations and shoot B-roll footage for me. I hadn't worked with this person before, but he came highly recommended by a good friend.

To be sure I was perfectly clear with him about what I wanted, including the types of focal lengths and angles I preferred, I created a fairly detailed shot list, complete with a few simple drawings, and we sat down to discuss

it over coffee. He seemed comfortable with what I was after, and very professional. Though he was displaying all the right signals, I was somewhat anxious, simply because I knew how important the program was, and to some degree I was relinquishing directorial control to a stranger.

A few days later, when I had a chance to look at the footage he had shot, I noticed something immediately. For some reason it looked better than most of the B-roll footage I was used to getting from other camera operators. At first I wasn't sure exactly what it was about the footage that made it look so pleasing and professional. But soon I began to notice subtleties. First, I realized he had shot a good deal of footage (in this case mostly trucks moving on highways and airplanes taking off, landing and taxiing on runways) using long focal lengths. While most operators I knew would almost certainly have gotten in as close as possible to the subjects, he chose to shoot some of the footage from a distance, while keeping a tight, steady frame. This had the effect of "squashing" the foreground and background, giving the overall image a pleasing, almost film look which, in those days was the Holy Grail for those of us in video production. I also noticed that some of the angles he had chosen were not typical. Some were low—at ground level, and others were high. He had also shot some segments with the camera slightly tilted as possible alternates of the shots I had asked for. So when the trucks and planes moved past, toward and away from the camera, as observers we were either looking up at them or slightly down, and at times slightly off kilter—again, resulting in fresh, interesting perspectives. It occurred to me that the combination of these subtleties made for some very nice-looking footage that added a noticeably professional look to my program.

A DIRECTOR'S COMMAND

Another experience shortly after this reinforced my belief that subtle techniques could have a significant effect. In this case, it was a seasoned, highly respected director I had the good fortune of working with. Watching him audition, cast, set up and direct a series of short vignettes became a wonderfully instructional experience for me.

One thing I noticed quickly was that he always seemed calm and courteous. Though at times I knew there were significant pressures on him—in one case an extreme time crunch—you would never have known it. I watched him converse comfortably with his videographer, crew and actors and move with a kind of subtle command through each scene. As I watched him work, I realized that when directing, I was not often so composed. I also noticed that he worked with actors in a subtly understated and collaborative way instead of being "dictatorial" (as I often was in those early days). In one case, when I could see that he was not getting the performance he wanted from an actor, he approached her and said, "I'm not really sure about this one, Anna. I guess we need to both feel clear on what we're after. How do you see this interaction?" He and the actor then had a discussion about the motivation driving the scene and this led to a suggested change in how the actor delivered it. Instead of playing it "big," the actor toned down her delivery and I could see this version was much more to the director's liking—and a more sincere, credible performance. After a rehearsal in front of the camera the director smiled and said, "Great! I think that's it. You good with it?"

"It feels right on," the actor said, beaming with satisfaction.

"Good. Then let's get this one on tape."

BREAKOUT 1.1 "THE EXCITABLE DIRECTOR"

I taught a producing and directing workshop for a number of years and was privileged to work with talented students from all over the world. In our week-long classes, each of my students would get a two-page script to direct. We had an excellent group of actors in residence, good equipment and plenty of crew members (the other students in the class).

I remember one young man in particular with an excitable personality. Prior to his turn, we discussed his scene, how and why he

(continued)

(*continued*)

had cast and blocked it as he had, what kind of performance he was after and any questions he might have had. I noticed as we talked that he was dying to show his stuff, and when he finally did start directing, he was nearly manic with excitement. He hurried from one spot to another, instructing the camera operator, prepping the actor, discussing sound with the boom operator, eyeballing his master shot and just generally landing all over the set in a kind of whirlwind of positive movement.

Though his energy was upbeat and confident, I could see it was irritating a few of the other crew members—and the actor. As the crew began working on some lighting adjustments, I quietly pulled him aside and said, "Everything looks good. How are you feeling about the scene?"

"Great!" he said. "It's going to be Dynamite!"

"Good," I said, "But do me a favor and remember something. One of your jobs as a director is to set the tone and pace. Everything you do and say emanates to the crew and your actor, and I think you may want to show them a bit more of a composed temperament. We can all see you're pumped and very positive about the scene, and that's great. But try bringing the excitement down a notch. I think it will pay off for you in terms of the actor's focus and performance and gaining the respect of the crew."

He took my advice and the crew and actor followed suit. The scene played well and although I could see that he was close to bursting at the seams with pride, he projected a composed, professional tone and earned a good deal of respect from the group.

THE POWER OF SUBTLETY AND NUANCE

Over a period of quite a few years and hundreds of experiences like these, I've become more and more attuned to the idea that these kinds of subtle nuances can have a great impact on a writer's, director's or producer's work.

I've also noticed that as powerful as they may be, these subtleties usually have a few interesting characteristics. In many cases, they are simple techniques instead of what some might expect to be creative "rocket science," and they are often overlooked. I believe this is at least partly due to the fact that the production process, especially for those new to the field, is often glamorized, with a good deal of attention focused on the technical and hardware aspects of the business. For many newcomers it's all about the cameras, the lights, the dollies or Steadicams. It's about shooting on location where passers-by stop to look for celebrities and ask if it's a commercial or a sitcom you're working on. Or it's about some new special effect in postproduction that's "Really, incredible, man!"

Those who decide to make writing, directing or producing a career and who invest a good deal of time and elbow grease into that aspiration, find that the real "magic" comes not through flash or technical wizardry, but as a product of plain old hard work and the less-than-glamorous skill sets we will explore in this book.

And with that, let's get to it.

2

SENSIBILITIES

"Can you feel the love?"

In This Chapter

Empathy: The Key Ingredient
Other Influences

I hate to admit it but I often tear up in sad movies. My wife calls me the Kleenex King because I never fail to ask her for a tissue (or three) if there is a poignant birth scene, a heart-wrenching war movie, anything having to do with harming animals or just general emotionally charged situations.

Why? I've been told I'm a sensitive person. Good? Bad? I'd say some of both. Empathizing and being considerate of others' feelings are both very important to me, and somehow, it seems, imprinted on my genes. Dealing with people who show a lack of consideration is one of my pet peeves. If I hold a door open for someone at a store and they walk past me without acknowledging my gesture of thoughtfulness, or at least offering a simple nod of thanks, I become irritated. If I get what I consider polite, thoughtful service from a person helping me, (often in a telephone service conversation) I make it a point to ask if I can offer kudos to his or her supervisor. And though I'm hardly wealthy, I usually tip generously when someone goes out of their way to offer good service.

EMPATHY: THE KEY INGREDIENT

You could say I empathize to a fault, often trying to sense how the people I encounter are feeling and thinking, and why. Many times my intuitions about them are correct, but sometimes not. In any case, the bottom line is this: For better or worse, I'm one of those people who *cares* about how others feel.

I tell you this not to gain your sympathy, pity or admiration, but to make what I believe is a very important point about the creative process:

> Being sensitive to others' feelings, attempting to empathize with them, can help make your writing, producing or directing efforts "honest" and credible.

If you have an empathetic understanding of, say, how a person who continually breaks the rules and regulations thinks and feels, the performance of a talented actor playing this type of role in one of your programs will almost certainly be "real" and convincing. And that "reality" will have come about as a result of two interdependent elements: the actor's talent and your empathetic sensibilities.

I once worked with a director who seemed to have no sense of empathy whatsoever. He was very terse, at times even rude, and often gave his actors directions like "No. You start here and end here." Or, "I need more pace on this. Let's move it along." I can't say that I actually saw him lose work or have to deal with actors' rebellions. I do know, however, that his sets and shoot locations often seemed tense and his dictatorial manner left little room for exploring other options in performances that might have benefitted him and his projects. On the other hand, I have seen directors work in very collaborative ways and when channeled properly (a skill we will discuss shortly), not only do they often seem to get better results, their crews and actors are typically more content and motivated to go the extra mile for them.

When you apply the idea that sensibilities affect performances, it makes perfect sense. When you write a scene about a seasoned truck driver who gets ticked off when he is disciplined by his boss, the writing will most

likely ring true and audience members will identify with it. Why? Because you've been able to empathize with that driver and sense why he might be saying to himself, "I've been on the road for all these years and you've been behind a desk. Now you're going to tell me how to drive? Give me a break!"

If an on-camera host in one of your programs is talking to your viewing audience about safety on the job of a telephone installer who frequently climbs poles and crawls into attics, your sense of what it might be like to do that work will influence the way you direct the host and what he might say.

Now this is not to say that you have to be a cry-baby to be a good director, producer or writer. You may not have shed a tear in years. Regardless of how you *react* to your sensibilities, whether it be emotionally or perhaps with more self-control than I can sometimes muster, the fact that those sensibilities are a part of your makeup, I believe, has an influence on your creative decision-making. And if I'm right on that, what should it mean to you as a creative person reading this book? I think two things:

> First, you should remain aware that your sensibilities will certainly influence your creative decision-making, and you should consider those sensibilities an asset to be nurtured. Second, because they reflect true human feelings, you should trust your gut instinct when it comes to judging a performance; deciding on the dialogue on a page of script; your decision to hire a certain writer or director; or making some important decision that will affect the writer or director on one of your projects.

OTHER INFLUENCES

Notice that I said your sensibilities will "*influence*" your creative decisions. I choose that word because as much as those sensibilities may be a part of your decisions, they are not the only criteria you should consider. The budget, the timeline, and your client's personality or desires are only a few of the many other elements that will also play a part in those decisions.

And this leads us again to that word "awareness." If you are aware of this "big picture"—your sensibilities and the other facets of production that play a role in your decisions as a writer, producer or director—you can not

only trust those gut feelings, but also put them in perspective with regard to the other important elements of the project.

If your gut tells you a certain actor is perfect for the role, but your client doesn't agree, you may have to adjust your thinking and perhaps look for another actor more suited to both your *and* your client's tastes. If you feel the script you've written highlights the subject perfectly, but your producer has reservations about certain scenes, your best bet is to consider how to make revisions that will satisfy both of you—or, if not both, especially the producer—the person who writes the checks and calls in freelancers or assigns projects. And if you're a producer and your budget won't support some aspect of what you would like to do with the project you're working on, you will be aware that you probably have two choices—find more money or change your mind.

The lesson is simple: your sensitivities to people, situations and the world around you, have a significant impact on your creative preferences. Often that's a positive thing because it gives you the ability to view a scene, story or character with the empathy needed to guide your actors toward delivering credible performances. At other times, however, if not handled properly, those sensitivities can become a detriment. Directors who ignore this truth and go overboard with "creative justification"—letting their right brain make significant creative decisions with no regard for the left brain "realities" of production—usually end up in the unemployment line! The successful writer, producer or director understands these influences and balances his decision-making accordingly.

BREAKOUT 2.1 "THE BRASH 'AUTHORITY': A DIRECTOR'S DOWNFALL"

I walked through our studio's master control booth one afternoon and was surprised to hear a freelance director who was new to our operation noisily insulting a camera operator for what he called a "^&%$ zoom!" Meanwhile the client, looking embarrassed and shocked, sat behind the director in a rear viewing area.

(continued)

(continued)

When he had finished with the camera operator, the director turned to the client and said something to the effect that he felt he should apologize for the poor work of this individual, who obviously didn't know what a smooth zoom and a medium close-up were. The client remained silent and red-faced, as the director made it clear that he was the creative authority in the house, and he had very little patience for "amateurs" that weren't up to his creative standards.

If I hadn't heard his narcissistic rant, I would never have believed someone new to our studio had said it.

A few minutes later, the departmental director stepped into the booth and sat with the client at the rear of the room (the department heads had a monitoring system in their offices which allowed them to see and hear what was going on in the "booth" and on the studio floor). The two conversed quietly and I realized the executive was apologizing, not for the camera operator, but for the director. The client nodded her head several times and smiled. I could tell she was glad the executive had come to talk with her.

The director was allowed to finish the studio portion of his shoot, which included a few more insults that day, and then he was let go. The additional two days of location work, which had already been scheduled, was assigned to one of our in-house directors as the "authority" was paid and escorted out, never to return.

I believe that most creative people have strong egos. Mine is certainly not weak. But I remain constantly aware of it and never let it encroach on my professional relationships. I try to always remember that I, like all other members of a production group, am *replaceable*, and overinflated egos often provide a fast track to the nearest exit.

3

PROGRAM INCEPTION: THE NEEDS ANALYSIS

"Awe, come on! Why can't I just be creative and write the darn script?"

In This Chapter

POTS? SAY WHAT?

My career in corporate media began as a kind of weekend and evening writer. I was working full-time for The Phone Company and writing scripts when I wasn't climbing poles or crawling through attics. Eventually I moved into a management position within the company and discovered they had a large, well-funded video department. So I set my sights on getting in as a writer. It took

a few years, but eventually I did get in and on my first day I was asked to attend a meeting with my new boss. "Great," I thought, "My first script!"

I was surprised and a bit confused when we sat down with a stack of sample writings and he said, "Welcome aboard, Ray. I want to talk to you this morning about POTS."

"Pots?" I asked, "Like pots and pans?"

"No," he chuckled, "like **P**roposal, **O**utline, **T**reatment and **S**cript. POTS. It's the acronym for the process we follow when we develop our scripts."

As you might guess, in addition to my surprise and confusion, at that point I was also disappointed! *"POTS? Give me a break!"* I thought, *"Just give me a script to write!"*

What I didn't understand in those early days was that my perceptions about scriptwriting for corporate media were in need of change. Up to that point, I had been writing primarily small jobs, often slide shows, for small businesses, and I'd been lucky enough to make a few bucks at it. What I was about to do was graduate into the big leagues. The jobs were no longer for small business owners and managers. In fact, most of the shows I was about to start working on had significant budgets and the clients were often high-ranking executives whose reputations, like the reputations of their departments and the company, were crucial.

I'll admit it took a while, but once I made that connection, the value of POTS began to sink in. I believe the most important of the four letters in that acronym (aside from the "S" for script, of course) is the "P." It stood for "Proposal" and I soon discovered it was a very short, but extremely valuable, front-end design document.

After spending the next 15 years at the company writing, producing and directing corporate programs, I left to freelance. No longer did I have to write those front-end proposals as a departmental policy, but to this day, on virtually all significant productions, I still do. Somewhere along the way, I began calling it a Program Needs Analysis, or PNA for short.

DESIGN: THE PROGRAM NEEDS ANALYSIS

Because that letter "P" is so important, I believe it's worth exploring. But first let me say that I also often incorporate the other two non-script

documents—the **O**utline and **T**reatment. Of those two, the treatment is the most often used because it provides the client with a visual and thematic sense of how the program will appear, *before* the process of scriptwriting—which of course will finalize those concepts. The Outline, on the other hand—meaning *Content Outline*—I use less often, primarily when the program is highly instructional or detailed, and a precise content presentation and structure are critical.

But let's get back to the "P" and that PNA.

If you're wondering why I've brought it up under the umbrella of "advance techniques," the answer is simple. Aside from writing the script, I consider understanding and writing the PNA an essential part of the initial production process. And that's because it provides, in a few simple pages, a *design "roadmap"* that can, and should, serve as a guide *throughout the entire production.* Before I discuss how and why that's the case, let's look at an example. I wrote the following PNA at the inception of an important production for an adult school in Oxnard, California.

TITLE:	Working title: *Oxnard Adult School: 75 Years Young!*
START DATE:	February 27, 2012
DEADLINES:	Various TBA: Video to be produced by the spring Western Association of School and Colleges (WASC) reception. Other materials to be produced and distributed as needed. All dates available by January 12, 2013
CLIENT(S):	Tom Cattan, Principal, Oxnard Adult School, Phone: 807-555-2508, Email: Tomcatt@CBLTE.com Sylvia Gomez, Vice Principal, Oxnard Adult School, Phone: 807-555-2506, Email: SGOAS@CBLTE.com
APPROVALS:	Tom Cattan, Sylvia Gomez, and the WASC selected reception committee members

PROBLEM: Academic and community members are not aware of the long, rich and important history of Oxnard Adult School, including the fact that this year will mark its 75th anniversary.

BACKGROUND: A Western Association of School and Colleges (WASC) reception will be held in the spring. This event will be a perfect time to offer a video presentation documenting the history of Oxnard Adult School in its 75th anniversary year. Other media, such as flyers, newspaper articles, and PSAs on radio and television will be produced as well.

The story of Channel Islands High School principal, Maria Gonzalez, offers an ideal example of how powerful and transformational the adult school experience can be, for both individuals and the community. Her account will serve as a centerpiece for the production. Other testimonials and interviews will also be included.

AUDIENCE:

Description: Oxnard community members, WASC celebration attendees.

Size: In the thousands.

Demographics: Primarily Hispanic, Spanish speaking, adult community members. This demographic profile applies to a significant number of migrant workers and families with migrant backgrounds. Strong family values and religious foundations are also valued by this group, as is desire to improve living conditions.

Education: A very small percentage of these audience members are college graduates, and many are not high school educated. Younger community members will be more likely to have high school educations and some college.

Age: A wide range, from teen and young adults to senior and middle-aged community members.

Knowledge level: Many audience members will know the Oxnard Adult School exists, but most will have very little in-depth knowledge about such things as times, locations, size, classes offered and potential impact on their lives and the community.

OBJECTIVES: This program will meet both motivational and informational objectives as follows:

Motivational: This program will motivate community members to regard the school in high esteem, value its presence in the community and, in appropriate cases, consider attending or seeking more information on how the school might benefit them.

Informational: Having viewed this program, audience members will be able to:

1. state that Oxnard Adult School has reached its 75th anniversary;
2. state that the purpose of Oxnard Adult School in the community is to help community members achieve personal and career success;
3. state that Oxnard Adult School has had a positive effect on students, enriching their lives, improving their futures, and helping to create exciting new opportunities.

UTILIZATION/DISTRIBUTION: This program will be shown at the WASC reception in spring of this year. It will most likely be presented via computer projection in a large auditorium. It will also be posted on the Oxnard Adult School website, and possibly be broadcast on local cable through Time Warner and the Oxnard Government Channel (26). To meet these distribution requirements, various distribution formats may be needed, including standard DVD and MPEG.

(NOTE: The PNA ends here. In this case, the client asked that I also include a brief concept or treatment.)

CONCEPT: A documentary-style program, roughly 10–15 minutes in length, would work well for this media need. Since Maria Gonzales, Principal at Channel Islands High School, was once a migrant worker and an Oxnard Adult School student, her profile would provide an excellent example for the entire program.

Maria's journey could be highlighted with historic images of Oxnard and the school. Other testimonials from students, teachers and Oxnard Adult School principal Judy Perkins, would add depth and richness to the message of how the school has helped shape the future of many individuals, and in

doing so has helped the community grow and prosper. A possible interview with State Superintendent of Schools, Martin Foster might also be included.

NOTE: A Spanish language version of this program might be a beneficial investment, helping to motivate non-English-speaking community members to consider the possibility of attending the school. Some additional editing would be required, but the translation and voice-over might be provided by an Oxnard Adult School staff member.

SUGGESTED PROJECT ELEMENTS:

- video projection for the WASC meeting;
- video PSA for cable TV—Time Warner and Channel 26;
- audio PSA for local radio stations;
- newspaper and magazine article(s);
- Internet postings;
- possibly, flyers for community distribution in markets, stores, restaurants and frequented places of business;
- a possible celebration-day auditorium projection, culminating with scholarship awards;
- possible awards to long-standing members of the school who have contributed a great deal to its success—teachers, administrators, volunteers.

WHAT THE PNA PROVIDES

I wrote this PNA as a front-end design for one of several projects I produced for Oxnard Adult School. Other than minor editing and changing names, phone numbers and email addresses, this is the version that was submitted and approved by the client—the school's principal. Here's a quick rundown of what it provided and why it was so important.

Client Contact Info/Dates

Basic, but important, information about the client and the deadline, all in one place. Phone numbers, email addresses, contact information for the

key decision-makers. I don't know about you, but if these types of important details are not all in one place, I invariable misplace them and end up digging through stacks of papers to retrieve them.

Got a Problem?

Whether a client realizes it or not, every project is produced to solve a problem, and that problem is the basic premise behind the need for the program—the core purpose justifying its existence. If the client can't provide it, it's up to you to figure it out. In this case, the client initially felt there was no problem. They simply wanted a video produced to celebrate their 75th anniversary and get word out to the community. I explained to her that community members, being *unaware* of the anniversary, including the school's longevity and history, *was* the problem.

Audience

A brief overview of audience demographics is crucial for writing an effective script viewers will identify with. Included in the audience section are:

Size

The audience size often dictates, or at least contributes, to how much budget will be appropriated for the project. The more people (usually employees) who will see it, the more budget it may warrant. This is especially true in large organizations and companies.

Age, Demographics, Education, Knowledge Level

Because in this case the WASC team was strictly an academic group, not an audience that might consider enrolling at the school, we decided to focus the program on motivating community members who might actually enroll.

And just who are these audience members? If they are all young, say, in their twenties and thirties, that would probably call for a different approach

than one for an audience of senior citizens? If they are all female that might call for a different approach than an all-male program. And knowing how they feel about a subject (their opinions and perhaps biases), can affect how a writer may present the information. If it's a program on a new company procedure, is the procedure generally perceived positively or as just "more rules and regulations passed down from 'the Ivory Tower'?" The Audience section of the PNA explores all of these audience elements and guides the writer, producer and director as the show is developed.

Objectives

Objectives give the program a clear direction and goal, or goals, to shoot for. They must be precise, (in most cases) quantifiable and achievable with the use of a video program. I often categorize them in one of three ways—informational, instructional or motivational.

- Informational objectives should be clear and concise explaining what audience members will learn from the program.
- Instructional objectives should be specific and quantifiable explaining what audience members will be *able to state or do*, having viewed the program.
- Motivational objectives may be less precise because they are a gauge of *feelings*, not actions (we will clarify this shortly).

Utilization

Utilization describes how the program will be used, and that, too, is very important. If it's a stand-alone program it must be effective with no other support materials or activities. For instance, if it's a stand-alone program on sales techniques, it must describe, demonstrate and discuss those techniques in order to be effective. If it is not a stand-alone program, that means something like a pamphlet or booklet—or perhaps a presenter—will provide some of the information.

I once produced a project that we designed as a series of sales demonstration segments. Because each of the segments was to be introduced by a

live instructor and discussions would take place after viewing, there was no need for a video introduction nor follow-up support material. We simply began each segment by fading up on a brief title and then the action, and each segment was ended by fading out.

Concept

In the case of this PNA, I was asked to include a program concept or brief treatment of how the show might play out, along with a rationale for that choice. This is something that may or may not be included in (or perhaps "attached" to) the typical PNA. Whether it's presented at this stage or not, however, it should be based in large part on the information brought to light in the PNA. This is another reason I write one on virtually all projects, and keep it on file. At various points during the development process, I read it over and ask myself if the decisions I've been making support what the client(s) and I initially outlined. When the program is shown in the client approval meeting(s), I bring the PNA to the meeting, hand out copies, and use it to discuss and refresh the client's memories about what we set out to do and whether or not we've met those objectives.

CONTENT CAUTION

One caution to keep in mind regarding PNAs should be explained to clients at the outset. The PNA is not a content document. If, in your initial meetings, the client wants to begin describing what should be said by the host or listing out the content points, you or the producer should tactfully make clear that although that content is very important, dealing with it will come in the next step. Initially, the PNA is strictly a tool for deciding how a program will be designed, not the information it will contain.

Speaking of information, however, as I said earlier, the "O" in POTS, Outline, is a useful document when a program is highly instructional or informational. It assures the client that the writer has indeed studied the subject and understands it well enough to write the script. It should present the information in a logical outline structure that can easily be "lifted" and shaped into script format.

THE INITIAL CLIENT MEETING

Corporate media clients come in all shapes and sizes. Some are demanding but respectful and reasonable, some are not. Some are dazzled by the production process and want to come along on all shoot days. Some want nothing to do with the project except to take the credit for it in the end. Most are responsible and, of course, a few are flaky.

The job of the corporate media writer, producer or director is to make the client feel as comfortable as possible—regardless of their personality type. That often means doing a little psychological profiling and offering production guidance and support as the project is being launched. If this is the client's first production, it also means explaining the process briefly but succinctly to let them know what to expect in the coming weeks. This explanation should include what will happen at each step along the way, and how they can be both helpful and involved to the degree they wish. A typical "overview" might go something like this:

> Today is what you might call the launch of a four-step process—research and scriptwriting, preproduction, production and postproduction. We'll start with the script phase. That actually begins by writing a Program Need Analysis or PNA. This will give us a solid design we can build on. It's not a content document, but rather a short overview of things like who the audience is, how they think, what might motivate them and how we can best communicate with them. After that and the important content research, we'll develop a content outline, and/or a treatment to give you a good visual sense of how the program will play on the screen. With that approved by you, we'll write a treatment to give you a visual description of what the program will be like and when that's approved we'll write the script—which is the most important document in this project. It's the visual framework for the program.
>
> When we have that approved, we'll move into preproduction. This is the phase when we'll make all the arrangements and do the scheduling for the production. During this phase, you'll be hearing quite a bit from me or an assistant about things like locations, props if we need them, employees who might be interviewed or demonstrate their

work functions. We may also cast a host or narrator for this program and you'll be involved in that also.

Once everything is scheduled, we'll move into production. We'll visit each of the locations and shoot the footage we need to edit the show together. You'll most likely be with us on the shoot, acting as an advisor, and, of course, you'll be able to approve what we're doing or suggest changes.

Finally, we'll bring the footage, along with any music and maybe graphics we've had an artist develop, to a video editor. He will put the program together, and again, you'll be involved and approve what we're doing. When we have an approved show, we'll create a master, and get the duplicates, or "dupes" made and distributed.

Keep in mind that the Program Needs Analysis—I call it a PNA for short—will be the design guide, so to speak, that we'll use and be checking on along the way to be sure we're on target. And at the end, when we're in those final approval meetings, we'll get out the PNA again to be sure we've done what we set out to. By the way, as important as the PNA is, a second element is also crucial: The *general quality level* of the production elements. For instance, is the sound clear and effective? Are the actors and/or voice-over narration credible and professorial? Are the employees used in the program presented professionally and credibly? Do executive interviews project dignity and command on the part of the company's leaders? And overall, does the program reflect a high level of professionalism to match the company's image?

If we get it all right, which I'm sure we will, you'll have a great program.

It's these types of courtesies and informative communications that keep clients and producers comfortable and confident that their project—which is probably costing considerable money—is in your good hands.

4

THE SCRIPT

There is always the typical way, and usually it's adequate.
You can get by on it. But how many of us want to be just "adequate"?
How many of us would rather elevate the quality of our work
from adequate to excellent?

In This Chapter

The Scriptwriter
Beware the Influence of Ego and Status
The Script
 Dialogue/Monologue: Contractions
 Pacing and Flow
 Getting a Feel for It
 Structure and Transitions
 Tell 'Em!
Approval by Committee
Saved by a Single Point of Contact
And Finally . . .

THE SCRIPTWRITER

I once hired a writer to develop a script for an important program on
employee benefits. When she brought me her first draft, I told her I'd like

to read it over at a convenient time, and meet with her later in the week to discuss any revisions. During that time, I read and reread the script, saw places where I felt improvements could be made, and wrote in what I felt were improved lines and screen directions.

The key words here are "wrote in." Being young, inexperienced and, I must admit, a person with a healthy ego, rather than bringing the writer back in to discuss my opinions and leave the revisions to her, I called her back in, presented her with a copy of her original script including my revisions, specific to the word, written in. In essence, rather than ask her to revise the script, I was asking her to create a new copy including what I had written.

When she looked at the script she turned pale and at first looked confused, then perplexed, and finally angry. "You re-wrote it!" she said. "You actually re-wrote it!"

Realizing she was ticked off, but feeling that I had done the right thing, I smiled and agreed. "Right, so if you can get that new draft to me by Friday, that would be great. I think we'll be good to go!" She did what I asked, of course, collected her check, then left the project, I'm sure feeling patronized and belittled.

In order to get exactly what I had wanted, I had delivered a slap in the face that she would not forget. She was a talented writer, but I didn't trust or allow her to exercise that talent. I chose to let my ego and opinions take over. We didn't work together again. Sensing her anger, I was hesitant to call her, and I'm sure that had I done so, she would have been "too busy" to take on a new project.

There is a back story to this incident that, at least to some degree, justifies my actions, but we don't have time for whining or excuses. The bottom line was simple—justified or not, it cost me a relationship with a talented writer and who knows how that might have affected my career from that point on.

So what is the lesson in this little tale?

BEWARE THE INFLUENCE OF EGO AND STATUS

Your ego and sense of status can have a powerful influence on your words and actions. Don't let them affect your relationships with creative people—especially writers and actors.

If, as I said, a good script is one of the primary keys to your success (and believe me, it is), you need to have solid relationships with good writers, and in order to create those relationships you must allow them to flex their creative muscles and gain respect for their work. If their work is not up to your standards, fire them and hire new writers. But don't patronize them by doing their work and then patting them on the back. And when you come across those really talented ones—treat them well, both personally and financially. They are invaluable!

THE SCRIPT

So it stands to reason, a good writer will write a good script, right? Most of the time, that's true. But what exactly is a good script? And what are the subtleties and nuances that make it better than just adequate? We don't have the time or space needed to cover every aspect of what constitutes a good script, but here are a few of the more important subtleties you should keep in mind when writing, assessing or shooting a script.

Dialogue/Monologue: Contractions

One subtlety that makes for a good script is dialogue or host monologues which include natural contractions and pacing. Now let's face it, including contractions—"they're" instead of "they are," "it's" instead of "it is," "it'll" instead of "it will"—would seem like a no-brainer, right? I can't tell you how many scripts I've read that contained few if any contractions!

I have to qualify this by saying that some scripts should be more formal than others and as a result have fewer contractions. A script about company policies or procedures, for instance, would probably be written a bit more formally than one about, say, customer handling or sales techniques. But in general, the use of contractions gives a script a natural ring that will make a host or actors in a role-play situation appear comfortable and credible.

Pacing and Flow

In addition to the use of contractions, most people converse in short verbal exchanges. Their interactions have a natural sense of pace and flow. And these

qualities of pacing and flow, though often overlooked by writers and directors, are also critical qualities of effective dialogue.

Several years ago I wrote a short, tongue-in-cheek script for a class I was teaching. The idea was to highlight how convoluted executive "corporate speak" could be. Although you will find Version #1 (immediately following) difficult if not impossible to understand, remember that was the intent. Just read through it and then check out Version #2.

VERSION #1

THE MEETING

FADE IN:

INT. EXECUTIVE BOARDROOM: DAY

Two high-level corporate executives are seated in a large, plush office. One is the CEO, the other is an Executive VP. They are engaged in a serious, very important strategic meeting. The Executive VP stays seated during most of the conversation. The CEO gets to his feet soon after the conversation begins and paces, thinking over each point made in the discussion.

 CEO
 Are they aware of our strategy? The vertical integration
 plan? You know, the revised version sanctioned by the Board?

 EXEC. VP
 Sure. The efficiency numbers alluding to our market
 posture are a part of the first section. Hell, it is obvious.
 Post-quarter numbers? Exactly. Annualized to include
 the relative shares of each capital driven element ... by
 weighted percentages, of course.

 CEO
 Those outlined in the general plan, endorsed section on
 diverse investment in human resources as opposed to
 technical micro-elements. So that is section five of the
 appended output of our quality caliber V-Code input data.
 The centralized input of invested members versus attending
 elements held at account level. Which means we will have it

both ways! The ramification listings inserted in vertically
integrating the relative weightings will contrast the calculated
indices based on consortium-level derivatives brought
forward from other applications!

 EXEC. VP
Which ... if projected three fiscal quarters into the future
and factored in with running M-load indices from 09 through
12 respectively, suggest that the deregulation strategy put forth
centralized consortium level—even with non-elemental infusion
runs—can bolster vertical enticement, subject of course to a
 series of policies ...
 (a sudden, depressing realization)
... deemed ... functionally ... *essential*! Damn! So what do we
 do? ...

 CEO
 (also depressed)
The *catch*! ... Of course! We will go over it again—this time
 in detail ...

FADE OUT:

As I said, convoluted! But remember, the point of the script was to show
how silly and convoluted executive conversations can be. Now, keeping
that description in mind, read a second version of the script.

VERSION #2

THE MEETING
FADE IN:
INT. EXECUTIVE BOARDROOM: DAY
Two high-level corporate executives are seated in a large, plush
office.
One is the CEO, the other is an Executive VP. They are engaged in
a serious, very important strategic meeting. The Executive VP stays
seated during most of the conversation. The CEO gets to his feet soon

after the conversation begins and paces, thinking over each point made
in the discussion.

 CEO
 Are they aware of our strategy?

 EXEC. VP
 You mean the vertical integration plan?

 CEO
 Right. The revised version sanctioned by the Board.

 EXEC. VP
 Sure. The efficiency numbers alluding to our market
 posture are a part of the first section. Hell, it's obvious.

 CEO
 Post-quarter numbers?

 EXEC. VP
 Exactly. Annualized to include the relative shares of
 each capital driven element ...

 CEO
 By weighted percentages?

 EXEC. VP
 Of course!

 CEO
 So it covers those outlined in the general plan, endorsed
 section on diverse investment in human resources as
 opposed to technical micro-elements?

 EXEC. VP
 Right on. Section five of the appended output of our
 quality caliber V-Code input data.

CEO

And that would mean the centralized input of
invested members versus attending elements held at
account level.

CEO

Excellent! So we'll have it both ways!

EXEC VP

You got it!

CEO

The ramification listings inserted in vertically integrating
the relative weightings will contrast the calculated
indices based on consortium-level derivatives brought
forward from other applications!

EXEC. VP

Which ... if projected three fiscal quarters into the future,
and factored in with running M-load indices from 09 through
12 respectively, suggest ...

CEO

... that the deregulation strategy put forth centralized consortium
level—even with non-elemental infusion runs—can bolster
vertical enticement, subject of course to a series of policies!

EXEC VP

Exactly!
(a sudden, depressing realization)
Policies deemed ... functionally ... *non*-essential!

CEO

(also depressed)
Ah! The *catch*! ... Of course!

EXEC. VP

Damn! So what'll we do? ...

CEO

We'll go over it again—this time in *detail* ...

FADE OUT:

Which version of this script would you say has the more natural pace and flow? Hopefully you said the second one. If you did, it's because the dialogue is paced quickly and naturally between these characters, versus the sluggish, chunky, unnatural style in the first version. And does the quicker pace, along with the focus on contractions, make it a better script? You know my opinion, what's yours?

Getting a Feel for It

One of the best ways to get that natural feel for good dialogue and host monologues is to use contractions, pace the words in what seems like natural rhythms and then *read and record* the lines either with a fellow producer, director or writer—or with your wife or a family member. When you play it back, listen for the natural, believable qualities that come with real conversation. Another way is to stealthily record real live conversations as they happen, and when you play them back, listen for the types of things we've been discussing.

BREAKOUT 4.1 "A FORMAL FAILURE"

I was hired to write a series of half-hour documentary-style scripts for a local college television station. The programs were part of a series of television courses on various sciences, which in my case was biology. The productions included an on-camera host and hostess—two college professors—and mostly stock footage.

Because the series was on such a break-neck schedule, the producer asked me if I knew of any other writers who would like to work on the project. I knew of an excellent writer, who himself was a college professor and who was eager to work on the project, so I made the recommendation and the producer assigned him a script.

We met the following week for coffee and I knew immediately there was trouble. The producer had essentially rejected my friend's

(continued)

(*continued*)

first draft, saying it was too formal and "stiff." My friend was a bit offended and very perplexed. He was an established writer who had published articles, literary criticism and even books. Though he had been a mentor of mine, he asked if I would read over his script and give him some input.

When I read the script it was obvious to me that although the writing was articulate and well crafted, it was also, just as the producer had said, overly formal and "stiff." One reason (you may have guessed) was a lack of contractions. When read aloud, the lines my friend had written sounded like content from a textbook rather than the conversational delivery of an on-camera host. In addition to a lack of contractions, his script contained words like "splendid" and "quite" and "wonderfully." In a book or print piece, especially one in his areas of literary analysis and criticism, the words would have worked perfectly. In the script this producer was after, they did not.

I met with him and, as tactfully as possible, told him that. I also added, "Try to write it very simply, just like a conversation."

"But that's what I've done," he said.

I explained the need for simple, everyday words instead of those with an "academic" ring.

"You mean dumb it down?" He asked, with a mix of bewilderment and alarm.

"Call it what you will," I said, "but it has to be '*real*'—clear, simple words meant to be spoken aloud, *not* read in print."

The end result was disappointing for him, me and the producer. He either couldn't or didn't want to adjust to the conversational style, and as it turned out that was his first and last attempt at industrial scriptwriting.

Structure and Transitions

Structure and transitions are critical in corporate media programs because they can have a profound impact on the script you may be writing or working with.

I once used this analogy of structure and transitions:

> Imagine your script is made up of content islands linked by transition bridges. The reader of the script, or ultimately the viewer of the program, is taken to these islands, one by one, in a logical order, by means of the transition bridges linking them.

If the structure is logical and the transitions subtle but effective, the result will be a clear, comfortable journey of enlightenment from which the viewer or reader will walk away knowing exactly what the writer had hoped to communicate. On the other hand, if the script is poorly structured and the transitions were weak, or even absent (which is sometimes the case, by the way), the viewer will end up getting some of the information, but often in a choppy or disjointed way.

Another analogy we could use (I love analogies) might be to imagine a well-structured script with effective transitions as being similar to a kayaker who is sliding along on smooth, clear water, having to read and understand a series of important signs (the content) on the river banks along the way. With a smooth, comfortable passage, the information is made perfectly clear and the kayaker has ample time to read and absorb them.

A poorly written script might include the same kayaker, but in this case, speeding along in rough, choppy whitewater. Both kayakers reach the same destination, and they're both exposed to the same content, but under much different circumstances. Unlike his counterpart, the kayaker in the choppy whitewater, will probably be much too busy steering and staying afloat to pay much attention to the content signs.

So, if we know what we want—solid structure and smooth transitions—the question is how do we get them? Again, the answer is not rocket science, but in at least one case a simple, well-known communication technique is a powerful solution. The legendary "Tell 'em" technique.

Tell 'Em!

Ever heard the phrase:

> "Tell 'em you're goanna Tell 'em."
> "Tell 'em."
> "Tell 'em you told 'em."?

It's a traditional three-step training and marketing structure that originated many years ago. It's also a time-proven winner when it comes to conveying information clearly. It's very basic, admittedly simplistic, and certainly not new or exciting, but it is extremely effective. I include it here, for that reason. Well-known and simplistic or not, it is worth a review. I'm not saying this structure should be applied to all scripts, but I *am* saying that many informational or instructional programs can benefit from this type of structure, or a *version* of it.

Here's how it works:

1. "Tell 'em you're gonna tell 'em" means you should first give your listeners a brief, general introduction containing the main topics you plan to cover.
2. "Tell 'em" means you then deliver the main body of your message by elaborating on those same topics in the same order—but, of course, in full detail. And finally
3. "Tell 'em you told 'em" means you should close with a simple summary that briefly reiterates what you'd like people to leave with in their minds.

Consider a very much abbreviated example.

You are writing a script about an administrator chairing a meeting to achieve three important objectives: (1) create a focus on costs, (2) review your staff's specific cost-cutting measures and (3) develop a plan to communicate those measures to your employee. Using the "Tell 'em" structure, here's an abbreviated version of what you might write.

```
INT. CONFERENCE ROOM: DAY
AN ADMINISTRATOR is seated at the head of a conference table. A group
of about six SUBORDINATES are seated around the table.
("Tell 'em you're gonna tell 'em")

                          ADMINISTRATOR
            Thanks for coming today. We've got some very important
      topics to cover. I first want to go over our expenses for the last
      quarter, then I'd like to cover the cost-cutting measures you've
```

each come up with and, finally, I want to talk about how we plan
to communicate these measures to our employees.

("Tell 'em")

So let's start with expenses. Bill, you can take us through each
cost category on the P&L statement for the quarter. And as we
go, I'd like to discuss each one in detail ...
(Bill covers P&L info)
Okay, so we all have a clear picture of what our costs have
been this quarter, now let's move on to cost-cutting meas-
ures. We'll start with Jim and move around the table. I'd like
all of you to take your time and be very specific about the
plans you've come up with.
(All plans are discussed)
Good, now let's cover what we plan to do to make our actions
clear to our employees. And I hope to also focus here on
telling them *why* these measures are important.

*(When all the content has been covered, we would end up with
the summary or ...)*

("Tell 'em you told 'em")

Well, I'd say this has been very productive. We've gotten
a clear focus on our costs, we've specific plans on how to trim
them significantly and we have a plan to tell our
employees exactly
what we're doing and why. The next step is action.
I'm very clear on all this, but I want to be sure you all are
as well. Any questions or concerns on what we've covered?

So what this administrator has just said was very simple, but extremely
clear and effective. Through him you told your audience what you were
going to say, you then discussed those issues in the same order but in much
greater detail and, finally, you summarized and asked for confirmation that
everyone understood.

Simple, direct, crystal clear!

As I mentioned, this solid structural technique can also be achieved by using *a portion* of the "Tell 'em" structure. As an example, a script might not need an introduction, depending on its use or intended audience. As mentioned earlier, I once wrote and directed a series of short, instructional vignettes that were part of a presentation followed by handout information and discussion. Since the discussion and handouts summarized the video, the vignettes I wrote had to cover only the Introduction and "body" or middle part of the structure—the "Tell 'em you're gonna tell 'em" and the "Tell 'em."

BREAKOUT 4.2 "MAKING 'TELL 'EM' CREATIVE"

I worked with a very talented writer on a project for the training department in a large construction company. We had been brought on to produce a video about how to dig properly. The video was being made for two reasons. First, the company had been experiencing an increased number of back injuries that appeared related to shovel work. Second, the company decided to provide employees with some instructional material in an effort to help lower insurance costs.

The problem we faced was how to produce a safety video on digging for construction workers who could think of about a hundred things they'd rather be doing than watching an instructional video.

The writer had decided on a humorous grave digging script to get the information out and keep the audience engaged. The interesting part was that although the script would be considered non-traditional, the structure the writer chose was the standard "tell 'em."

The story opened with a scene of two gravediggers in a cemetery. One was the grumpy "boss man" in charge, and the other was a dummy carrying out his orders (not the most original storyline but, as it turned out, very effective). It became clear immediately that the dummy did not know how to dig properly. As he started on a section of a grave, he leaned in and bent the wrong way, gripped the shovel close to the spade and twisted his back in ways that would certainly be very damaging.

The "boss" called attention to this and at the same time set up the introductory "tell 'em" part of the script:

```
EXT. GRAVE SITE: NIGHT
The BOSS watches BILLY, his clueless cohort, trying to dig,
but doing it all wrong.

                            BOSS
    No, Billy. No! Listen. If you are going to open this
    casket—and believe me you ARE going to open it—you must
    first dig it up in a way that doesn't make you worthless
                          to me!

As the boss takes the shovel from Billy and prepares to dem-
onstrate, he says ...
NOTE: SUPER TITLES PER DIALOGUE: 1. Hold the shovel correctly.
2. Position your body to limit back strain. 3. Use foot to
help. 4. Bend at the knees when lifting dirt.

                       BOSS (CONT.)
    First, you must hold the shovel correctly. Second, you must
    position your body correctly to take the strain off your
    back. Third, you must use one foot to help dig and, finally,
    you must remove the dirt bending at the knees—not
                          your back.

He hands the shovel back to Billy.

                       BOSS (CONT.)
                    Now, show me.

The pair then went through the digging process step by step.
Because it was a humorous vignette, the "Tell 'em" structure was
not apparent at all. It was there, however, as a subtly rein-
forcing structure that made the show flow smoothly and logically
from point to point. In this case, we felt that a summary was
not necessary so this was a partial, but very effective, use of
the "Tell 'em" structure.
```

Can you look back at the script segment we just covered and find the transitions? Here are three:

- "So let's start with expenses."
- "Let's move on to cost-cutting measures."
- "Good, now let's cover what we plan to do to make our actions clear."

You can see that in each case these transition lines move the reader or viewer from one topic to the next—just as a bridge would move a traveler from one island to another.

Taken together, structure and transitions are a critical, but often overlooked, nuance that can greatly improve a script in a subtle but very effective way.

APPROVAL BY COMMITTEE

As a young scriptwriter, I remember sitting in a conference room meeting at a college in southern California. I had been hired to write a script for a production that would deal with maintaining a healthy diet for children, and this was a script review meeting.

I was seated at a U-shaped table arrangement surrounded by eight professors. One was my client on the project and the other seven made up the "committee." My client thanked everyone for attending and introduced me. Next, she read the objectives we had established for the project and then said something like:

> "As you all know, we're here today to offer Mr. DiZazzo some suggestions on the first draft of his script. I know you've all had a chance to read it, so I'd say, let's just go around the table . . ."

It was then that the nightmare began.

In short order I heard that we should: Change the setting to the inside of a supermarket in the fruit and vegetable section; we should include children in the cast (and, by the way, the person who suggested this added that she

had a daughter just about the perfect age); we should restructure the middle section to present carbohydrates first; we should section the program into five, 10-minute modules; we should create fruit and vegetable graphic signs with happy faces; we should . . .

In case you haven't gotten the point yet, here it is in a nutshell: Any time you go into a meeting in which a group of people—a "committee"—will offer suggestions on your script, you are very likely to leave the meeting with a mountain of notes, a splitting headache and, at best, a cloudy understanding of what to do next.

You can understand why this "approval by committee" process is the nightmare that keeps many of us writers up at night. It comes about for several reasons, but here are what may be the two most prevalent—and irritating:

- People love to give creative input on things like scripts, at least partly because even though it's an informational, non-theatrical script, it's just a bit like "Hollywood," and who doesn't want to have a say in the creative process! It feels kind of 'important.'
- Everyone has their own ideas when it comes to creative elements, they're all different and everyone is convinced their ideas are the best!

Which often leaves the writer in a daze and wondering why in the world he would take on a project from these people.

SAVED BY A SINGLE POINT OF CONTACT

You can't always escape the dreaded "approval by committee" meetings, but there are things you can do to avoid it most times. First and foremost, remember to tell your client when the script process is just beginning, something like:

> The script is a kind of framework or guide book for the producer and the director. It's a critical element and, of course, we hope you can help us with constructive comments and ultimately a quick approval. And speaking of comments and approvals, it's very important that you

be our single point of contact in the soon-to-come script meetings. We've found that when groups are involved in projects like this, the result can be confusing and they often slow things to a crawl. It would be great if you could get input from whatever sources you feel are appropriate, decide which ideas you feel are essential changes, and then be the tip of the spear, so to speak. We want to be accurate and deliver a great script—and, of course, we want to be sure to make your deadline. Working this way makes that process easier, more accurate and definitely faster.

It never hurts to reinforce this idea as the production moves forward. This, of course, applies not only to the script but also the screenings in postproduction. In fact it's even more important in the latter phases of the process—for financial and logistical reasons. It's a pain in the rear and sometimes costly to rewrite a script, but it can be a budgetary and logistical disaster to have to reshoot scenes or create new ones following a viewing of the initial cut of the program. If you can get that "single point of contact" commitment from your client at the outset, you can be assured your immediate future will be much less convoluted, frustrating . . . and just plain angry!

AND FINALLY . . .

As a producer or director you may not write scripts yourself, but you will be involved with them directly and you will be held accountable for how well they work on the screen. As we've said, "adequate" is fairly easy to achieve. But adequate productions are also easy to forget, and quick to be criticized. Keeping the ideas we've just explored in mind will help you write or fine-tune scripts, and allow you to offer solid input to the writers you collaborate with.

5

PREPRODUCTION

The Devil may be in the details,
but so is a successful shoot!

In This Chapter

I remember one of the first corporate programs I directed.

It was a studio shoot with a professional host, three cameras, props, a set and a full studio crew. As I mentioned earlier, the company I was working for had a large, well-funded production department. Though I had been working at the facility for some time and seen quite a few directors in action, this was my first big project and the pressure I felt was enormous. I remember having mixed feelings on the evening before the shoot. On one hand,

I was eager to get in the director's chair and show what I could do. On the other hand, I was also secretly wishing the shoot would somehow be delayed so I wouldn't have to face the terror of walking into the studio with a Screen Actors Guild (SAG) actor and a crew of professionals waiting for my command—not to mention a group of department managers watching to see if I was going to sink or swim.

As it turned out sinking was not on the cards and, to my great relief, the shoot went very smoothly. The reason it worked out so well, I believe, was that I had thought through and planned virtually every detail of the shoot, using a kind of mental, walkthrough exercise in the days leading up to the event.

THE VIRTUAL WALKTHROUGH

I had first listed all the details that I felt were important, and then *visualized* myself moving through the events of that day as I felt they would unfold. If I had spoken this visualization out loud, it would have begun something like this:

> Tomorrow at 7:30 I walk into the studio. Who's there? The technical director (TD), the three camera operators, the floor manager and the assistant director (AD). Per our discussions, he has stopped on the way in, brought the bagels and other breakfast stuff needed, and set it up in the green room. The full crew is in by 7:45—their call-time. I speak with them and make sure all the studio equipment and lights are on and working.
>
> At 8:00 the host shows up. Who meets him and what happens? I have the AD waiting at the front desk to meet him, introduce him to the crew and make our introduction. I ask that he get comfortable in the green room. In the green room are bagels, fruit, coffee, juice and water. Once I'm sure everything on the set is okay, I tell the crew I'll be back with talent in a while and I'll have the host out and ready to rehearse and record in about 20 minutes.
>
> I go back to the green room and look over the wardrobe choices the host brought. I make the decision and the host knows to get to the dressing room and report to the stage in 20 minutes. I ask the AD to

supervise this, and also meet the client and show them to the control booth, where I'll be ready to meet them. At 7:50 I ask for all crew on set, check out the the intercom line (often called PL or private line) and all equipment and make sure everyone is in place and knows what they're doing . . .

This little preparatory thought-stream is paraphrased, of course, but you get the idea. I wanted to be sure that I had thought out "everything" and prepared myself to move through the sequence leading into the actual production. I had also marked my script with the camera numbers and take points, and rehearsed in my mind a play-by-play of exactly what would happen during the entire shoot. I've done the same thing on many shoots—both studio and location: visualized what I've outlined—thought it over in detail and mentally recorded when and what would happen, and who would take action. This may not be an essential preparation step on all shoots, especially as you become more proficient, but I can assure you that if you have an important or complex shoot coming up, if do this, *you'll be ready*.

CRITICAL CHOICES

But before that shoot day, there is work to do. Some of the most important decisions you will make in preproduction include:

- Script breakdown and scheduling
- Location scouting
- Blocking
- Casting.

Let's look at some important considerations applicable to each of these.

Script Breakdown and Scheduling

Though some directors choose to have an assistant break down their scripts and do much of the scheduling, I always choose to either do both myself or be very heavily involved. My reasoning (please excuse the repetition) is to be keenly aware of all aspects of the upcoming shoot. I realize there are

many directors who would make the case that you are paying the AD to do much of this type work so the director can focus on important directorial responsibilities, such as casting and blocking. I agree that's a logical argument, but I would have a difficult time adhering to it. I simply feel much more comfortable having "my arms around" just about all the details involved in my shoots, and I feel I can also give myself ample time to work on blocking and casting. With that said, I do believe in delegating as much as possible—but often under my close supervision.

Before the days of word processors (I realize how old that must make me sound), I did all breakdown and scheduling work cutting and pasting paper forms I had developed. These days there are widely used and very effective breakdown and scheduling programs for all types of productions. I typically use two breakdown structures—what I call the "Shoot Breakdown" and an "Elements Breakdown." And though I work on a word processor, I still do a good deal of it manually. Figure 5.1 offers a block diagram highlighting how these two breakdowns differ. For practical examples of both, see Appendix 1 and Appendix 2.

Whether it's electronic programs or a notepad and pencil, as you look over these breakdowns, you'll see they help the preproduction staff accomplish three important things:

First, the Elements Breakdown allows the director or assistant director, (AD) to separate out and list the important elements required during a production, for instance: talent, locations, props, wardrobe, equipment and graphics. With these elements listed and grouped, the AD, or the production assistant(s) (PA) will have a concise, organized list to work from.

Second, when developing the Shoot Breakdown, the director segments the script into numbered scenes. These scenes will be referenced throughout the production by the director, AD, PA, the actors, the editor, in some cases crew members and the client and producer.

Finally, the Shoot Breakdown facilitates rearranging those scenes from **script order** into **shooting order**. As an example, if you have several exterior scenes to be shot at the same place, but they appear at different places in the script, you'll want to schedule and shoot them together. This means shooting out of script order. The rearranged list of scenes eventually gets dates, days and times added and thus becomes a basic shooting schedule.

Two Types of Script Breakdowns

SHOOTING SCRIPT

Shoot Breakdown

Director makes a list of all scenes, numbering each in *script* order

Director rearranges the list of numbered scenes into the most efficient *shooting* order

Director may pre-block scenes, noting key aspects, special equipment or needs

Elements Breakdown

A.D. and/or P.A. group key elements: talent, locations, props, etc. and all special needs

A.D. and P.A.s arrange to acquire and schedule all items noted in the Elements Breakdown

A.D. and P.A.s develop a production package—all paperwork, contacts, elements and details—the "Master File"

Director and A.D. apply dates, days and times to the shooting order list, thus creating a basic shooting schedule

Figure 5.1 Two types of script breakdowns allow the director to work on blocking and other visual details, while the AD and/or the PA work on acquiring elements needed for the shoot. For an example of both, see Appendix 1 and Appendix 2.

Location Scouting

Location "surprises" can make or break a shoot.

Whenever possible, I scout all locations (especially exteriors) in person and leave plenty of time to work out things like where the sun will be, what sound problems might arise, how we will secure power, parking,

extraneous issues that might pop up, and any other unplanned details that might affect the shoot.

An all-night shoot some years ago drove home for me the importance of this prep work. We were shooting SAG actors on a lawned area just outside the maintenance yard of an upscale golf course. The scene was to involve the actors walking across the area as they talked. We had large HMI lights supplying background and direct "moonlight" and several smaller, fill lights along the path the actors would walk. All was going well as we rehearsed the scene until suddenly a set of huge, soaker-type sprinklers came on! The actors and crew all ran for cover, and, of course, we had to immediately power down the lights for fear of shock.

I had scouted the location several days before, but I had overlooked the possibility of sprinkler problems. My first thoughts were that our shoot for the night might have to be scrubbed. As it turned out, we got lucky. The AD had the telephone number of the grounds supervisor. She immediately called him and we found out how to turn off the sprinklers. In a short time we had re-lit an adjacent area and, although we were put behind by the incident, with a few schedule adjustments, we still got most of what I had planned.

The point is obvious. If you shoot at any unfamiliar location, be absolutely sure to take into account all possible problems that might arise. You may feel it's the AD's job or some other crew member, but regardless of titles or responsibilities, in the end the buck will stop with you.

BREAKOUT 5.1 "MALIBU BEACH DISASTER AVERTED"

I once directed a public service announcement shoot in Malibu Beach, California. A week before the shoot I scouted along the shore and found a perfectly isolated little open spot between two beach houses. My AD called the city and got us a permit to shoot there.

In thinking through the possible problems that might arise, I decided to check the tides, future weather and speak with the neighbors on both sides to make them aware of the shoot and be sure they

had no concerns. At the first house all went well. The residents had no problem with a video crew, and even offered to allow us to use their patio if we needed a break from the sun. The second house was built into the side of a cliff and was elevated on a group of large concrete pilings. As I walked toward a stairway leading up to the house, I noticed a workman taking measurements amongst the pilings. Initially I was going to walk past him and head up to the front door of the house, but I decided to stop and to talk with him. I introduced myself and let him know our plans.

"When are you going to do this?" he asked.

"A week from this Wednesday," I said.

"You better pick another day, in fact you better pick another *week*," he said, "On that Tuesday we're going to have heavy equipment down here to start repairing these pylons."

"Heavy equipment?" I asked.

"Right," he said. "Real heavy, and real *loud* equipment."

"And when does that start?"

"We're bringing in the equipment on Monday and we start the next day."

"For how long?"

"About a week."

Thanking my lucky stars I had stopped to talk to the man, I imagined what we would have been in for. A crew of production people, and three actors showing up to a beach where bulldozers and drilling rigs were in full work mode! I called my AD, she was able to adjust the schedule, and we shot when the construction work was completed.

Blocking

With your locations secured, you can pre-block scenes. As I believe I've mentioned, some directors prefer to block in real time during the shoot. I prefer to have a very clear sense of what will happen in production and that means thinking it through in advance. This allows me to not only clarify in my mind how the scene should play with the greatest impact,

but also to plan for any equipment or special needs required for the scene. See Figure 5.2 for an example of a simple blocking diagram.

Some directors prefer to work from storyboards. This requires (at least minimal) art skills or the extra budget money needed to hire an artist who can sit with the director as he describes the action and approximate focal length of each scene—close-up, medium shot, wide shot, etc. Storyboards most often provide an eye-level view of the actors and this can be very effective. Personally, I like the bird's-eye-view, so I save a few dollars on most shoots. Figure 5.3 provides an example of a simple storyboard.

When shooting actors in role-play scenes, I typically block starting with a master shot, usually a wide angle, and then shoot appropriate coverage of individual segments of the scene. Considering the characteristics of the location and the script, I will often look for what I call "off" angles. These are non-standard perspectives that I feel will offer a fresh or interesting

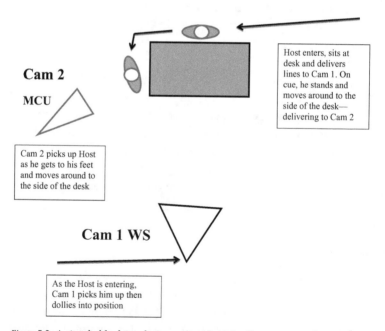

Figure 5.2 A simple blocking diagram provides a bird's-eye-view of the scene, allowing the director to plan out camera positions, moves and coverage.

Director's Rough Storyboard Sketch

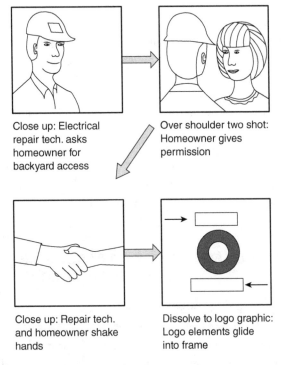

Close up: Electrical repair tech. asks homeowner for backyard access

Over shoulder two shot: Homeowner gives permission

Close up: Repair tech. and homeowner shake hands

Dissolve to logo graphic: Logo elements glide into frame

Figure 5.3 Some directors prefer visualizing eye-level-type, simulated camera shots instead of overhead camera positions. A storyboard provides this, but it takes an artist, or, in the example shown here, simple images drawn by the director.

perspective. Standard eye-level shots are fine in many cases, but where I feel something fresh would enhance the production, I'll usually try it.

As an example, I once directed a program on substance abuse in which one scene involved two employees secretly meeting between their work trucks to exchange money for drugs. I could have simply shot the scene with standard, eye-level angles and it would have been fine. But I thought if I could somehow *reveal* the two men making the exchange and "secretly" peer in on the action, it would add suspense. To do that, I shot the scene of the two men coming together in three basic angles. For one, we mounted the camera very low on a dolly that moved out from the rear of one of the

trucks under the bumper. This gave a sense of discovering them and watching from a low, secretive position. I shot the same coverage from a camera mounted directly overhead, roughly 15 feet in the air. We accomplished this by sending the camera operator up in a pre-arranged boom truck. In this case, viewing the transfer of money and drugs taking place became very dramatic. In addition to shooting a medium wide shot of the angle, I also shot a close-up of the two men's hands coming together making the exchange. The result was a scene with a dramatic sense that enhanced its impact significantly.

If I had not thought through and pre-blocked this scene in advance, I probably would not have come up with it in the haste of production. Even if I had thought of it, I would not have had a boom truck available for the overhead shot, and possibly not the dolly for the low angle.

BREAKOUT 5.2 "BLOCKING IN ADVANCE VERSUS SPONTANEITY"

Over the years, I've listened to the argument about going into a shoot with no pre-blocked shots versus planning angles and blocking prior to the shoot. Both ways of approaching a shoot have merit.

The spontaneous approach offers an unstilted, very natural version of a performance. If two actors are scripted to have an argument, as the director watches the two rehearse on the set or in the field, he begins to develop the blocking that feels most natural based on the performance. For instance, if there is an argument and one actor moves toward another in an angry confrontation, the director might feel that as that action is happening, the camera should go to either a high or low angle—an off-kilter shot that would punctuate the emotions being expressed. The result would be a scene or portion of a scene with (assuming the director's instincts are accurate) a very "real" or "honest" feel. Those who subscribe to this type of directing would argue that pre-planning the blocking and the camera angles would "can" the performance and give it a less than a completely natural feel.

There may be some truth to this, but I'm not convinced. In my mind, a director whose instincts are accurate could just as easily visualize and block such a scene during preproduction. In addition, serious logistical problems can develop during a spontaneous shoot. Suppose, as an example, on the set the spontaneous director decides a high, overhead angle is exactly what's needed to most effectively record the scene. If the director doesn't have a crane available or some other way of getting the camera above the actors, he is out of luck. If the shoot has a substantial budget, a crane and many other production accessories, for instance a dolly or Steadicam, may be available. Most corporate shoots, however, do not have exorbitant budgets. A director who thinks through and plans his or her shoot in advance will know they will need that crane or Steadicam and can show the producer their suggested blocking, talk over the advantages and make a convincing case for the producer to include it.

And again, if his or her other sensibilities are accurate, the shots will play just fine.

Another argument for pre-blocking is the reality that corporate programs are not high drama or feature films. Most times, they are not meant to evoke intense emotional responses. Typically, they are designed to demonstrate some ability or suggested a way of working.

With these ideas in mind, I pre-block every scene and note all equipment, props, wardrobe, and other elements needed.

Casting

Casting, of course, involves actors. And since our next chapter deals with that topic, I'll briefly mention a few notes at this point and leave much of the detail for the coming pages. As I've mentioned casting is one of, if not the, most important activity you'll carry out as a director. For that reason you should leave ample time to watch your actors perform and also ample time to judge their recorded performances later.

If the client or producer becomes involved in casting, which is not unusual, you may lose some of your decision-making influence. In that case,

you should be sure to make your opinions known and, in doing so, suggest the actors you feel would be most effective in the roles and why. If you feel the choices made by a client or producer will be a detriment to the program, you're placed in a precarious position. To offend a client or producer by suggesting that their decisions are not credible, can cost you future work. By the same token, to shoot the program with actors you feel are not up to the level required can result in a program that is not credible.

The solution?

I experienced this on a program produced for a large company. After holding auditions to pick an on-camera host, I attended a meeting in which the client watched all the recorded performances and made a choice. I felt his choice (an actor I'll call John) was the one I would have chosen as a runner-up. The producer also attended the meeting and he agreed with the client. They then asked for my opinion. I don't remember exactly what I said, but paraphrased (including another fictional name) it was something like:

> "I like John's performance. He's good. And he has a nice sense of maturity. But actually, my first choice would have been David. I think because although he's younger, he would bring a sense of energy to the screen and that would wake the show up. Also, his read was great, and as you saw, he takes direction well."

We discussed David's read, looked again at the auditions and the client still preferred John. I was lucky in this case because even though John was not my first choice, he was a very capable actor and he did a fine job in production.

The bottom line is, *do* let the client and/or producer know your opinions. That's what they're paying you for. But do so in a way that is not offensive and remain open to making a client's or producer's choice the best you can.

CLIENT HANDLING IN PREPRODUCTION

I try very hard to make clients feel at home and comfortable on my shoots. I've found that one way to do that is to downplay the "Hollywood" production

angle. I remember one director I saw in action, who did the opposite. He felt he should play up a kind of "Hollywood glitz" image on his shoots, as a way of amplifying his own importance and making the client feel inexperienced. This might have worked for him to some degree, but for a limited period of time. Inexperienced clients would most likely go along with this type of treatment until the "dazzle" wore off or until the "Hollywood" director started making unprofessional goofs—which also seemed to happen to this director fairly often. Then, for him, reality would set in and he would find himself in a bit of a pickle.

I find that when clients are treated as professional colleagues, a good deal of tension is removed. Production days, which often involve long hours and stressful situations, become much more pleasant and relaxed, and clients tend to more readily share their input, which can be critical for a successful shoot. I also find that when clients are treated in this way, they quickly become believers in the value of corporate media, and thus future supporters.

There are also difficult clients, however, and when faced with these types of individuals, a delicate dance becomes the mode of operation. Clients who demand certain things on a shoot, must be "stroked" as needed, but also made aware that decisions about things like blocking, camera work, actors' performances, dialogue and so on, are best left to a professional like yourself. Getting this point across gracefully can be easier said than done. Most times just a simple explanation will suffice. For instance, if the client asks for a certain type of shot and you feel it would be a mistake, you might say something like:

"I think I see what you're after, Bill. That sounds fine, but I'm a little concerned about continuity—how that will cut later in postproduction. We have to be sure the scenes will all fit together neatly."

Or,

"Sure, I think we can try that. But do me a favor; let's wait until I get the coverage I've planned, so I know I have what I need in the edit suite."

Usually this simple explanation solves the problem. I've had clients who have taken offense, however, when their suggestions aren't acted on immediately. In one case, as we were shooting an exercise professional going through a routine in a fitness center, the client suddenly said, "We need a high angle of this. I'll get us a ladder."

At first I tried to head off the suggestion, saying "I think this angle will work fine and we're a little behind schedule." But a quick glance at the client told me he was ticked-off. So I bit my lip for the good of the project and the future. I said, "Actually, it would work well as a possible alternate. Good idea! Let's give it a shot." And we recorded the high angle. This shoot was the first in a series of modules for this client and I felt that any other response might have backfired and put that future work in jeopardy. As it turned out, the high angle was a good idea and we used it in the final version of the show! Dealing with the client through the rest of the shoot, however, was not easy. I resorted to a mixture of responses to his "demands," but most times I simply gave the client what he wanted. In the end we used some of the shots and not others. But he was happy with the results and our working relationship, which set the stage for a positive, productive future.

I suppose there is no single solution for handling difficult clients, but these are a few of the most important ones:

- Never get defensive.
- Always remember they are paying the bill.
- If you sense they need a little extra stroking or perhaps shared credit as the director or writer, simply go along with it gracefully.

WORKING WITH THE PRODUCER

Some producers can be demanding and unyielding, a lot like difficult clients. Others will respect your role and empathize with you, knowing the pressures and difficulties of your job. These producers will most likely provide you a great deal of creative freedom and their personal support. When you get that support, consider it a *valuable asset* and *use it wisely*. Also, be sure you continually *earn that respect* by doing excellent work. Always be mindful

that the producer reports to someone, too, and at his or her level, the conversations (and pressures) are often about money and corporate politics. If you return the support you've received by doing excellent, budget-conscious work, and keep your clients happy, believe me, you'll be considered a valued asset. And that means there's a very good chance you'll be back on the job soon.

BREAKOUT 5.3 "THE CASE OF THE STUBBORN PRODUCER"

I was hired at the last minute to direct a project that had hit some rough going in preproduction. The client and a public affairs representative had requested a meeting with the producer and me on the Friday prior to the shoot, which was scheduled for the following Tuesday.

It became obvious as we began to talk that, although the script had been approved, the client did not like the role-play scenes in it. She felt they were corny and preachy—and she was right. However, being new to the production process, she had been afraid to say so, and now found herself on the verge of having to spend a good deal of money for a project she didn't believe would succeed. That was the reason she had brought the public affairs manager with her to the meeting—to act as a supportive voice.

The scriptwriter had been paid for the script and was out of town, virtually all arrangements had been made and the producer was convinced the script was fine. All this led to nearly an hour of awkward back-and-forth arguing between the producer, the client and the public affairs manager, with neither side about to give in.

I was caught in the middle for most of the meeting, and, as I said, I agreed with the client and PA rep. The script was corny and preachy and I knew it would be difficult to make it work. But I had to handle my opinion with kid gloves, for a several reasons. First, if I took the side against the producer, I was sure he would take offense and that

(continued)

(continued)

might end our working relationship. On the other hand, the public affairs manager was a person I had also worked with many times and we had struck up a friendship. If I took the producer's side, this would offend him and most likely damage that relationship. And finally, I felt sorry for this client. She was new to the corporate media process and found herself in a difficult situation, to say the least.

When it seemed we had reached a stalemate, I had an idea for a very simple script concept that, although not flashy, seemed it might make for an interesting program. I was lucky with the timing because just then the dreaded question I was hoping would not be asked, popped up. The producer turned to me and said, "You're a writer, Ray, what do you think?"

He, the client and the PA rep looked at me and waited.

"You know," I said, "something interesting just occurred to me. I think I have a way we can keep the same general framework, but give it a fresh twist." Then I described the idea, which did not include the corny role-play. As it turned out, everyone liked it, so we decided to go with it. This got me off the hook in one sense, and allowed the producer and the public affairs manager to save face.

It meant I had to rush home, however, and write and prep a new script over the weekend, but it solved the problem and turned out to be a program we were all proud of.

6

TALENT

The question is, will they believe?

In This Chapter

ROLE-PLAY ACTORS: YES OR NO?

As you probably know, in the business of filmmaking the general term used for actors is "talent." In corporate media, talent also includes employees who might be used as actors or interviewees. Regardless of what they are called, the most important thing to remember about actors is this: *If you decide to use actors in role-play situations, they can make or break your program.*

I qualified that statement with the phrase "in role-play situations" for an important reason. There are many cases in which, although you

may initially want to use actors in role-play scenes, you should probably consider other options. Why? One of the most common criticisms of corporate media is that the acting is corny or unbelievable. So, as a producer, you need to ask yourself a few questions before making the decision:

- Will actors and role-play vignettes *really* help the show accomplish its goals? Or do you want to use them because it's cool or "Hollywood," or simply because you *want* to direct actors in character-type scenes?
- Are quality professional actors available in your budget range and at your location?
- If professional actors are indeed called for, and they are available, will the script be well-written enough to make the role-play segments credible and believable?

Later in this chapter we'll explore some alternate possibilities for getting your message across effectively, but for now let's move ahead on the assumption that you have made the decision to use actors as role-play characters.

NUMBER ONE AND . . . ONE

On my personal list of the most important media role-play elements, talent and the script come in as a tie, at number one. The reason is simple: Most audience members will put up with mediocre lighting or poor sound quality if the talent and script are fantastic. They will not, however, put up with a beautifully produced program if the script or actors are bad. I've walked out of many theaters shaking my head, having seen movies filled with expensive special effects, but not memorable or moving in any way. Why? They had tons of state-of-the-art effects on the screen, but the story (the script) was poor and/or the characters (the talent) were not strong or credible enough to keep an audience engaged.

Some might argue that the director is the most important element in producing a motion picture, whether it is a feature or a corporate production. The director is certainly crucial, since he will interpret the script and bring it to "life" in recorded segments. Also very important is the editor who will arrange, pace and connect those "live" segments into a larger

whole. But if the script or the actors are bad, there is little even a talented director or editor can do to make the project work.

We've already discussed getting that good script, so now let's talk about talent, including the subject of casting, which we touched on in the last chapter.

TALENT TIMES THREE

There are three general categories of talent that you work with as a corporate producer or director:

- professional actors
- employee "actors" or interviewees, and
- executives.

For the moment, we'll separate out employee "actors" and executives for two reasons. First, although they come under the heading of "talent," they are not actors. Second, they are employees, but each requires special handling. We'll cover these two groups in the next chapter. For now, however, let's stick with the professionals.

Professional Actors

I use the term "professional" here to include both union and non-union actors. Actors who are members of the Screen Actors Guild (SAG) or American Federation of Television and Radio Artists (AFTRA) are union professionals. But there are also many quite talented non-union actors who may be affiliated with local theater groups, schools or agencies. Whatever their affiliation, the two instances in which you will work with them are in auditions and casting during preproduction, and in the studio or on location during production.

Casting and Auditions

If talent is critically important to your program, how you choose that talent is just as critical. Casting means selecting talent at an audition. Auditions

involve watching that talent perform and choosing the most talented actors for your project. A few things to remember about casting and auditions are:

- *Always record* auditions for viewing later.
- Make auditions as *non-stressful* as possible.
- Try to leave plenty of time to work with the actors and get to know them.

Accomplishing these things means that during casting sessions you should have at least one person as an assistant. He might start and stop the camera, handle a waiting area for the actors, and provide them with copies of the script page(s) you've decided they should read—hopefully a single, carefully chosen script page. If you decide to audition using several pages, it may be too much for the actor to absorb and work with successfully. A single, well-chosen page or two can usually provide what a director needs. Or, if you feel you must see the actor work with several different types of scenes in different parts of the script, try to make them short pieces, instead of full pages.

In some cases, you or your assistant might read the dialogue of the roll "opposite" the actor being auditioned. I've also found that if you have several actors waiting, it can be fun and a very productive exercise to bring in two or three actors at a time and let them read opposite each other, switching roles and trying different ways of playing the scene.

This, by the way, is one reason having ample time and recording the auditions is so crucial. Working directly with the actors or being fully immersed in the audition scenes makes it difficult to recall which actors stood out and why. Sitting down later in a quiet room and going over the recorded sessions will allow you to pause and "rewind" if necessary, look for important subtleties in the performances, and make clear judgments about the actors' skills.

Prior to the auditions, whenever possible I like to give actors time to read and get familiar with the script pages, and I don't mind them keeping those pages in hand as they perform. My feeling is that auditions are, by their nature, highly stressful interactions. Actors should be given every opportunity

to go into an audition with as much of a sense of calm and confidence as the producer or director can provide. Keep in mind, however, that unions may consider it chargeable time if you forward scripts to actors prior to the auditions and have them memorize segments on their own time.

Key Attributes

I try to keep four qualities in mind when casting and auditioning actors:

- Ability
- Range: Taking Direction
- The Look
- Personality and Attitude.

Ability

Can the person act? Yup, it sounds like a no-brainer, but it's the first and most important question of all. And history (many of the past performances we see in corporate media), tells us that for a significant number of producers and directors, the answer is not quite so simple.

So, let's elaborate on the question in search of an answer. As you watch the actor perform, ask yourself:

Does he convey a truly **believable** character on the screen?

Will the audience be drawn in by what he is doing or saying?

Will the audience accept the **content** delivered by the actor as credible?

The only way to find the answers to these questions, of course, is by directing the actors and watching them perform. So, ask yourself another question:

If I watched this performance as part of the intended audience, would I cringe, shake my head or chuckle at any part of it?

If the answer is "Yes," well, there's another no-brainer—chances are this is not your person. But suppose the performance seems fine. The actor is sincere and believable. The next question should be: Can he *take direction?* In other words, if you decide to hire this actor, and in production you want the performance to change, can they adjust accordingly on the spot?

BREAKOUT 6.1 "GETTING THE PERFORMANCE"

As you know, a well-written script is a necessity in producing an effective, well-received program. Having excellent talent to enact that script is also a major element. But achieving the best from both requires solid performances, and that brings us back to the director, who is tasked with getting those performances.

One of my directing workshops focused almost entirely on getting solid performances. During one of those sessions, a gentleman from a large company was assigned to direct the first scene with an on-camera host walking in front of a picturesque harbor, introducing viewers to the area.

We selected and blocked the shot, set up the camera, and, after a sound check, we were ready to go. At that point the student director walked through the shot with the actor and offered direction. I'm paraphrasing, but he said something like this:

> *"Let's start here and walk this way. When you reach this point, you can turn and gesture out toward the harbor. After that, finish the read on a positive, upbeat inflection, maybe give the audience a smile and a thumbs-up gesture at about here, and you'll hear me say cut."*

The actor went through the scene for take one. After saying "cut," the student director paused for a moment, then from behind the camera said, "On this next take, maybe you could pick up the pace a little."

The next take went a little faster. The director seemed intent on "directing," but unsure of what to ask for at this point.

I pulled him aside and said, "What do you think?"

"I'm not sure she got the turn and gesture just right," he said.

"Are you game to try something different?" I asked.

I explained what I wanted him to try and, though he seemed unsure at first, he agreed. He walked over to the actor and said, "This might sound a little crazy, but I want you to forget everything I've told you up to this point. How to walk, how to gesture, when to turn—all that stuff. Okay?"

The actor hesitantly agreed.

"Good," the director continued. "Now, take a few seconds to look around at the harbor while I talk with the instructor, and then I'll have you tell viewers what you think of this incredible place."

After a few moments the director returned. The actor glanced around, smiled and said, "It's a gorgeous spring day and this harbor is beautiful. It's like a postcard."

"Great," the director said, "now do me a favor and take a few minutes to think about that, then we'll rehearse the lines a few times, and I'd like you to let the audience know those feelings of yours. Okay?"

"Sure," the actor said.

Given the challenge of using her acting skills to communicate the essence of the scene, instead of a series of demonstrated, "old-standard" instructions, the actor rehearsed a few times, grasped the sense of the scene, and delivered a bright, happy, wonderfully sincere performance.

The director came to me later, smiled and said, "So the lesson is, don't over-direct, right? Just give 'em what they need and let 'em go."

"You got it," I said.

Range: Taking Direction

Many times I've answered the question of range in an audition by asking an actor to deliver the lines they've just read, with a completely different performance. As an example, assume the actor has delivered the following line to another actor in a grateful and sincere tone:

"Thanks for the support. You've really been a big help."

You might then ask for the same lines delivered with a strong sense of sarcasm. If the actor can convincingly change the performance for you right then, chances are good that they'll be successful on the shoot. Then again, you might take it a step farther and ask for a third type of performance—for instance, have them deliver the read with joy and excitement. If they can do all three to your liking, chances are you're in very good hands with this actor's ability. The next question then, might be: Are they willing to take direction? We'll discuss that shortly in the "Personality and Attitude" section of this chapter.

BREAKOUT 6.2 "DIALOGUE DEBATE"

I directed a short, humorous piece that required an actor to speak with an Irish accent. He did a fine job in the audition. His accent was prefect, and he had what I felt was the perfect Irish look. On the day of production, he did a fine job until we came to the final line in the last sequence. The script had been about how no one in his village would give him credit for important work that he had done, such as building a church steeple and laying "every stone" of a cobbled road into town, but because he had been caught drinking one too many beers, he immediately got named as a drunk.

The final line in the script read, "But you drink an extra pint, mind you!"

The actor was insistent that he say the line without the last two words, "mind you." I felt they sounded very "Irish," and closed out the scene better, so I told the actor I'd prefer he kept those words in. I could see he didn't like this. "I've studied how the Irish speak," he said, "and I really don't think it's necessary. In fact, I think it takes away the humorous punch."

I thought about that and I didn't agree. But I wanted him to feel comfortable that I was listening and considering what he wanted, so I said, "Okay, I'll tell you what. Let's do it both ways and I'll pick the one I like in post (postproduction)."

He still seemed hesitant, "I just don't think you need it."

"Honestly, Dan," I said, "personally, I do like it with the final two words kept in. They seem to close the scene out nicely, and with a music sting there, I think it would work great. But I'm willing to listen to and consider it your way. And with both reads I can decide in post."

He chuckled sarcastically, "We both know which one you'll choose."

"Well," I said, "we'll see."

"Look," he said, "will you just trust me on this. It really works without those two words."

At this point I was getting upset. I felt I had been more than fair and open to his interpretation of the line, but he wasn't willing to concede that my interpretation could possibly be a good one. Meanwhile, the small crew we had that day was standing idle, awkwardly waiting for a decision. So I felt it was time to put my foot down. "I'll trust you enough to consider the option," I said, "but I also trust my own instinct, and my gut tells me it's better with the words kept in. So we'll do it that way first, then we'll get one your way, and I'll decide later." At that point I motioned to the crew to get ready to record.

He shook his head sarcastically and that did it for me.

"Let's take five," I said to the crew, and I called the actor aside. I told him in a calm but decisive tone that I was the director, I was responsible for the end product, and I wanted the scene recorded the way I liked it. I went on to say that as a professional, I expected him to understand that and give me the performance I wanted—to the best of his ability.

Well, he finally did give me the performance, and I did record a few takes his way. But in the end, that bit of resistance and his stubborn attitude left me with a poor opinion of him, and some level of doubt about what might happen on another shoot. These are the types of obstacles a director doesn't need on top of the other pressures that come with the job. As a result, I did not call him again, and I'm sure if he acted the same way with other directors, his career would be short-lived.

The Look

With a solid understanding of how crucial casting is, an actor's look becomes an interesting part of the equation. Simply put: An actor should look as you and the audience might imagine their character would look in a real-life situation.

This may not be as simple as it seems. An actor playing the role of a management employee, for instance, should look managerial, right? But this is a very broad description since managers come in all shapes and sizes. To clarify, the specifics of the job or situation might come into play. For instance, is the manager harried or under stress? Would he be mussed or unkempt? Or would the character seem to be a manager who is unflappable, neat and perfectly "manicured" down to the cufflinks.

An actor being used as an on-camera host should project a look of credibility and often a possible connection to the subject of the program. For instance, an on-camera host in a program about construction safety might appear to be a rugged, "no-nonsense" individual. An actor playing the role of a retail sales person should look the part, but again, in this instance, sales people come in so many shapes and sizes, more detail about the job or situation might be needed to clearly focus on the character type.

And sometimes it's nice to change things up. I had a friend who was directing a program on truck driving safety. He said he wanted to get my opinion on a host audition segment, and, of course, I expected to see a fairly rugged, road-weathered "guy" in front of the camera. To my surprise he had chosen a woman! Although somewhat attractive, however, she wasn't your local "pretty princess" type. Looking as if she'd traveled a few roads herself, and speaking with a slightly graveled voice, she exuded a kind of subtle toughness and command. My initial question was whether the audience—mostly men—would identify positively with her. Would they feel instruction from her was valid? As I watched her perform, it occurred to me that not only would she come across as credible, she might also instill a sense of pride in some drivers, knowing that such an attractive member of the opposite sex was representing their rugged line of work.

In short, she created a kind of tough "you go girl (and guy)" air on the screen that I felt made her unique and engaging.

In another case, when casting a humorous video that involved a person (a web-hacker type) who was to appear in a dark cellar from behind a "mountain" of pizza boxes, a friend's first inclination was to cast a very heavy person. After giving it some thought, however, she decided that if the person were extremely thin, it could offer a bit of humor that might add to the show's impact. It worked fine.

Personality and Attitude

Another issue that could make a significant difference in your production is the actor's attitude. At the risk of using an old standard corporate cliché, it's important to make sure that the actors you hire are "team players." That's right, as you work with them in the audition setting, ask yourself if they are the type that would be willing to take direction and get along with you and the crew, often working under "no frills" conditions.

I believe all creative people work for personal satisfaction and recognition, but a team player is one who can put aside his own immediate needs when necessary to create a positive work environment for the crew and the production. Not all actors are team players, however. Unfortunately, some tend to get a bit "heady," and this can slow down or even stop a shoot depending on the actor's personality and "demands."

I once had an actor insist (*after* he had been booked and the shoot was scheduled) that a chair and a water bottle be kept just out of camera range whenever he was on set, so he could sit between scenes. He justified the demand by saying he had a sciatic nerve problem, but it became obvious to the crew and me that the chair, the water and a person to make sure it was available was more of a status symbol than a physical need. Wanting to sit between scenes is understandable, but the actor should have considered and mentioned this in the audition. The proper way to approach it would have been to explain the medical condition in advance and ask politely if a chair could be provided. In this case it was not a request but rather a "must have," a politely framed demand, and

not in advance, but on the spot. As I thought back on our audition, I recalled that there were signs that something like this might develop. He had seemed a bit aloof as we worked, but I ignored my instinct because I admired his performance. Had I to do it again, I think I might have said something like this to the actor: "We'll be working in the field—an actual field—for quite a bit of this shoot, and it'll be pretty much a no-frills situation. It will be dusty and possibly pretty hot. Do you feel that's an environment you can work in?"

The point? Consider an actor's personality during the audition and if there is any chance it might be problematic in production, broach the subject directly before you book and schedule the actor.

THE VOICE-OVER OPTION

There is a way a director can hire and direct actors, but in the event they don't perform as expected, avoid being stuck with unsatisfactory performances. I call it the "voice-over option." It simply means using the video portion of a role-play scene (which by itself can be very convincing even if the actors' spoken lines are not), then recording voice-over narration to describe the action instead of hearing the actors' voices.

Or, instead of using this technique as a fix, a writer can simply write the talent in as a voice-over scene from the start. For instance:

EXT. HOUSE: DAY
A telephone truck pulls up out front. A repair tech. gets out, puts on his tool belt, and heads for the front door.

 HOST V.O.
 If the telephone technician arrives on time,
 that's a good first sign.

The tech. reaches the front door and rings the bell. The door opens. It is a woman. She and the tech. converse politely.

 HOST V.O.
 Next, find out if his attitude is positive and
 professional . . . and if he appears clean-cut.

```
INT. HOUSE: DAY
The woman lets the tech. in. The two move into the family room and
begin discussing a telephone on the edge of a coffee table. The tech-
nician picks up the phone and begins working on it.

                          HOST V.O.
           If all seems well, invite him in, explain the
                 problem and let him go to work . . .
```

You can see that in this case, although the actors performed the appropriate action, it is the voice-over that tells the story. The same technique can be used allowing the actors' voices to be heard under the voice-over narration, not audible enough to be the main dialogue, but just enough to give the scene more texture and a sense of reality.

There is yet another benefit of using a technique like this. You can often cast employees as your actors since they don't have to actually perform scripted lines. A director can simply say, "Don't worry about any scripted lines, just follow company protocol when you get to the front door and speak politely. And when you get in the house, as you check out the phone, just say and do what you normally would."

Several years ago, I directed a sample commercial as part of an educational project. The objective of the commercial was to motivate viewers to purchase a very dependable brand of watch. Because politics at the producer's level became involved, I was "strongly encouraged" to use an actress with gorgeous European features, but inadequate acting skills. Despite her beauty, I had no idea how I would get an acceptable performance from her, but a few days before the shoot I had a brainstorm. I knew that if such an attractive and elegant-looking actress was seen but not *heard* delivering her lines, her silent performance could appear credible. I also felt that if I could work with her in a voice-over session, we might be able to focus on, and polish, small segments of a script, even down to the individual lines—which is exactly what we did.

The commercial became a dimly lit, black limbo shot of her writing a note to her boyfriend under the light of a single lamp. The boyfriend, we were to find out, was extremely unreliable and always late. As she wrote the words on her note, we heard her tongue-in-cheek thoughts in voice-over

declaring that if he didn't get himself a new, dependable watch (the brand we were pitching, of course), their love affair was over. The dim lighting, her beautiful features, a simple white night dress and the carefully crafted voice-over made the scene a success.

The bottom line, as I've said, is that talent is always crucial, and if you *do* decide to use actors in role-play scenes, remember that you have several creative options to help you succeed.

7

DIRECTING ACTORS ON LOCATION OR IN THE STUDIO

"Let the fun begin!"

In This Chapter

Tradition Versus Corporate
The Director as Protector
Employee "Actors"
 Employee Interviews
Executives
Executives on Teleprompter
So . . .

Over the years, I've found that many times (especially if the actors are truly talented) less direction leads to better performances. I recall reading an interview with a famous feature film director talking about working with two A-list actors on location. When asked how he directed them, he said something like, "I just get the two of them together and we talk about the scene. Then I go away and come back a little later and we shoot it." No doubt that was an over simplification on the director's part, but to a significant degree it's accurate. Good actors will give you good performances—often with very little direction.

With that said, however, I do make it a point to always give actors a clear sense of what the program is about, its intended goals and the part their role will play in it. I also make sure to solicit in advance any questions they may have about the script, the shoot or any aspects of the production. And if they prefer that I become more specific about the performance (some actors like directors' specific instructions), I'm always happy to do that.

TRADITION VERSUS CORPORATE

There is a tradition of professional respect among actors and directors that goes something like this: *A director should not give the performance to the actor, but rather let the actor give the performance to the director.*

Translated, that means a director should not dictate every specific on the performance, thus turning the actor into a parroting individual with no creative contribution to the scene. Ideally, the director will give the actor a comfortable feel for the scene at hand, a sense of what he feels the scene should accomplish and let the actor contribute their part in the performance. The two can then discuss and collaborate on any adjustments the director feels are in order.

This is certainly a valid concept. Actors are creative people. As I mentioned earlier, like all creative people they thrive on personal accomplishment and recognition. If they believe they are simply being "used," they will feel they are being robbed of the creative expertise they bring to the project.

On the other hand, it is mostly dramatic performances that these traditions apply to. An actor who is operating a widget machine in a corporate training program has no dramatic qualities of which to be robbed. The topic is strictly instructional. Many corporate programs involving actors fall someplace in between these two extremes, and it is up to the director to balance creative input and corporate necessity to work productively with his actors.

If there are any character or dramatic qualities required of the actor, I try to give them the most freedom I possibly can. But, as I've said, I also remain available at all times to provide specific input. And when the performance is not what I was hoping for, I try to work with the actor to achieve it. Often times this is a simple matter of performance level. If the

actor is overplaying the role, I try suggestions like "That was nice, but what if we brought it down a notch?" Translated this means "you're over-acting," but it's courteous and allows the actor to work out the adjustment for the next performance. If, on the other hand, I said "I like that, but starting on the second sentence you were overly emotional, and near the end please give a serious grimace directly to the camera and emphasize the words 'so now we know!'" the actor might feel a little embarrassed and limited.

Another approach that often works for me is to try to take the actor out of a character mode and encourage them to simply be themselves. On many occasions I've said something like this to actors, "You know the way you're doing this is nice, but I get the feeling that if you tried to *not* be this character, and just played the scene as *yourself*, it might be a little more natural. I know that may sound a little strange, but let's try it."

BREAKOUT 7.1 "ILLITERACY: A DIRECTOR'S MISINTERPRETATION"

A colleague of mine found himself in a pickle after hiring a novice director on an important production about illiteracy.

The project was a short promotional video to be played on TVs in public government offices such as the Department of Motor Vehicles and in Post Offices, where people were waiting in lines. It was produced to highlight the problem of illiteracy, and encourage adults who were embarrassed because they couldn't read to "come out of the shadows" and seek help.

One short scene is detailed below: The script had previously established the characters and the primary topic. Bill was the illiterate, embarrassed father of Stacy, a young woman.

```
INT. LIVING ROOM: EVENING
Bill is seated on the couch watching a football game on TV.
His daughter, Stacy, watches him lovingly from the kitchen.
```

(continued)

(continued)

> NARRATOR V.O.
>
> Those with literacy problems can be content enough
> most of the time, especially in the security and
> comfort of their own homes.

If I were the director of that scene, I believe I might have had Bill seated quietly on the couch in a passive but positive frame of mind, and his daughter watching him with a compassionate smile. For, me the key interpretive words in that scene would have been "comfort" and "security."

The director, however, had a different interpretation. He gave Bill, a gentleman who, by the way, was considerably overweight, a huge bowl of popcorn and a large soft drink. And he wasn't just watching a football game, he was cheering for his team, bouncing up and down on the couch. As for Stacy, watching him from the kitchen, she appeared light and bubbly and, to a large degree, sharing her father's excitement.

The scene, combined with the voice-over, actually appeared comical.

The fault was the director's interpretation, or more accurately, his misinterpretation of the script. It would be one thing to see Bill quietly secure and comfortable in his home as the script indicated, but to see him cheering and bouncing removed any empathy we might have had for him and, as I said, the whole scene became laughable.

Interpreting the script is one of the director's key roles. His job is to visualize and record the script in a way that "brings to life" the message the producer and client have approved. In this case, that interpretation made the scene not only ineffective, but also embarrassing.

My colleague ended up having to re-cast and re-shoot the entire script.

As I said, however, corporate media is not high drama. And there are times when it is simply more expedient to provide a specific direction. When this is the case, I usually preface it with something like, "If you're

okay with it, in the interest of moving us along, I'd like to give you the read I'm after on this." Corporate actors usually understand, and are fine, with this approach. I might then follow with something like, "Keep it very upbeat and positive in tone, and when you get to the line about the accident, try a pause for a few seconds after you say it. I think if those words sink in a bit, it will be more powerful. Okay?"

In the end it boils down to getting a feel for the actor's personality and the needs of the production, and balancing them for a solid, convincing performance and a productive working relationship.

THE DIRECTOR AS PROTECTOR

I also try to be protective of the actors I work with, and make sure they know that I recognize their value and importance. If the videographer or the sound recordist, or even the client, begins to push an actor toward a certain performance, I'll usually politely stop them. And I am always ready to praise an actor for a good performance—especially if we've worked hard at getting the scene right. When I see an actor do a scene well, I love to say things like, "Fantastic! You nailed it!" or, "What a wonderful performance!" or, "How nice! Amazing!" When you do this, you'll see your actors beam with pride.

EMPLOYEE "ACTORS"

Remember this: *The key to achieving good employee acting performances is to* **not** *make them act.*

Employees should only be asked to demonstrate some aspect of their work in front of a camera. And demonstrating is very different from acting. As an example, if a program is on the subject of how to operate a forklift safely, an employee should not be asked to act out a scene in which they must convey a character other than themselves doing what they normally do. Employees are not actors, and 99 percent of the times they are asked to act, the result is embarrassment for them and a loss of credibility for the program. On the other hand, employees who operate forklifts are the perfect subjects

to demonstrate how it should be done. So how do you get the performance without the acting?

Again, the word is demonstrate. Visualize these two examples:

Employee Acting

Example #1: As the director walks the employee through the shot, he says:

Director: "I'd like you to come in this way and hit this mark as you step onto the forklift. Be sure to keep your body open to the camera so we get a nice, complementary angle. Before you start to back up, you turn and deliver your line as if your co-worker is standing right there."

Employee Demonstrating

Example #2: The director stands with the employee at the forklift:

Director: "What I'd like you to do is show me the right way to get on and back up the forklift. We'll follow your actions. And this is important—we don't need you to act. Just show us how it's done right. And I'll have John standing back here. So just show us what you'd naturally do and say to him before you start backing."

You can see that in the first instance the employee not only has to worry about doing his job correctly, but also which way his body is facing, how he moves and how to deliver a scripted line to a spot behind him—imagining it's a fellow employee. In addition to this direction, there is a good chance the videographer will also offer his two cents as the scene is being recorded. Comments like "If you could turn just a little more this way that would be great!" are very common from camera operators. And the sound recordist might chime in with "Could you speak up just a bit, please when you turn your head? We lose our level." The result of all this "constructive" input would be a scene that other employees would probably watch and either shake their heads at, or perhaps chuckle with embarrassment for, their co-worker.

In the second instance, however, the employee can simply do what he does every day. And this director would very likely get together with the camera and sound operators and say, "Do me a favor, and don't offer any suggestions. I want the employee to go through this naturally. We'll just follow her to get the coverage we need. If something goes wrong with the shot or the sound, let me know."

Employee Interviews

Employees are often asked to be interviewed in corporate media programs, and for good reason: They are the experts in the subjects the programs are about. Depending on how those interviews are carried out, the result can powerfully influence an audience, either positively or negatively. And, although it might seem like a different set of circumstances, again, the key word is *acting*—or, rather, *not* acting.

Even in an interview, if an employee is made to say scripted words or turn in certain ways, he is *acting*. I recall when I first began directing I was told that the typical way an employee should be interviewed was to ask him or her to repeat back to me the questions being asked as part of their answers. This, I was told, would assure that the subject of the interview would be made clear to viewers. In other words, if the question was, "How seriously do you and your co-workers take safety procedures?" I should say something like this to the employee: "I'll ask how serious you are about safety procedures. When you answer, try to start with something like, 'As far as safety procedures are concerned, we are very serious about them.' Then you can elaborate."

The intent with this technique is valid. If an employee is not guided correctly in an interview sequence, his answers can lack context and a clear relationship to the subject at hand. But 'guiding correctly' does not have to include making him or her say specific words in particular ways.

In the interview just mentioned, I would have first created a series of questions that would most likely include the context in the answer(s). That would allow me to keep the interview as a simple, relaxed conversation between me and the employee. I might have said something like: "So tell

me about safety procedures in general. How do you and your co-workers feel about them?"

As the employee answered, I would listen carefully for the proper context and the right words, visualizing how the scene would play on the screen. If I didn't hear them, or get a comfortable feeling that the answer would be clear to viewers, I would probe a little more. For instance, I might say, "Do *you* take them seriously? Tell me how you feel about them?" Or, "I'm just curious. If it were up to you, how would you tell co-workers about the importance of safety procedures? What would you say?"

With this type of questioning, the interview becomes a natural conversation—which is exactly what's needed—but it is being directed to produce the answers the director is after. The difference between this approach and asking employees to say specific lines can be significant. Viewers will hear and sense the difference and they will be much more likely to take the conversational approach seriously.

Obviously, the idea is to set employees at ease, not focusing on the camera, lights and production aspects, but rather on your relationship with them. And be sure to have a set of carefully written questions prepared for an interview. I often start employee interviews with a standard introduction: "Please don't pay attention to all this 'stuff' (the production equipment). This is really just a conversation between you and me. And don't feel like you have to get every answer perfect. The truth is, most of what you say won't even be used. I'll pick out the few small pieces that work. So we can just talk and whatever you say will be fine. Okay?"

Following this, I often start with some sort of off-topic conversation, just to get the employee relaxed and talking. I might say, "By the way, have you been with the company for quite a while?" Or, "Well, you're my last interview for the day. I get to head home soon. And fight the traffic!"

Finally, another good technique is to cover the interview in at least two focal lengths—a medium shot and a medium close-up. Recording a brief cutaway never hurts either—something like a few seconds of the interviewee's hands in his lap often works well. These will allow you and the editor to select and cut together parts that otherwise might result in unsightly jump cuts.

BREAKOUT 7.2 "INTERVIEW CREDIBILITY"

Employee interviews can provide a good deal of credibility and influence when recorded correctly. They can also convey a lack of credibility, however, and in some cases, a corniness that results in laughter instead of buy-in by the audience.

I once saw a director playing back his "dailies" for his producer, in which a lack of credibility and an abundance of corniness were the case.

Interview credibility requires a natural delivery that suggests it is a piece of a conversation that was not set up or rehearsed, but spontaneous—as if a camera crew just happened to catch it by chance.

This director had "caught" just the opposite. He had instructed the interviewee, a telephone company operator, to repeat back to him a series of scripted lines meant to validate a new work procedure. I don't remember all the lines exactly, but one was something like:

"I think with this new procedure in place, we can be much more productive."

Repeating it back to the director, who coaxed him into giving several different "reads," meant he had to act. And asking employees to act is almost always embarrassing and laughable. That was the case with this interview. The employee looked stiff, obviously attempting to emphasize certain words, and as if he wished he could be anyplace but where he was.

Instead of asking the interviewee to repeat scripted lines (which should never have been written in the first place), if the director had simply sat down and had a person-to-person conversation with the employee—subtly guiding the discussion to cover the correct content points—he would have gotten credible, believable sound bites that would have been sincere, and very possibly capable of positively influencing other employees' opinions on the procedure.

EXECUTIVES

Although executives are also company employees, I consider them a sepa-
rate group simply because of the way they are handled and the information
they tend to contribute.

Executives are typically best handled with kid gloves. A director should
make it clear that he is very much aware of how valuable the executive's
time is, and how grateful the director is to be given some of that time. Then,
using the same techniques as with employees—just a simple (guided)
conversation—and shooting ample coverage is the way to conduct the
interview.

EXECUTIVES ON TELEPROMPTER

Instead of being interviewed extemporaneously, executives will often
record messages reading from a teleprompter, and they will typically show
up with an assistant or two. The presence of this high-level "gang" can be
intimidating and exert significant pressure on the director to get the execu-
tive in and out as quickly as possible. If the executive is comfortable and
natural in front of the camera, this is no problem. One or two takes may
be fine. But that is not often the case. Most times, when an executive reads
from a teleprompter, the message sounds stilted, at least to begin with. The
director's job is to make the executive look his best, and this means getting
the message recorded as naturally and convincingly as possible. When you
consider the pressure to keep the time to a minimum and the goal of getting
a solid read out of a person who is not an actor, you can see the dilemma.

My solution is to first sit down with the executive and say something like
this: "Thanks so much for giving us a bit of your time to do this. Believe
me, I'll do everything I can to move this along quickly because I know how
busy you must be. I've found, though, that going through the message
several times usually makes it smoother and more convincing, and I want to
be sure you look and sound your best. So, I hope you won't mind repeating
this several times."

I then set about getting the read as natural as possible. Just as with
interviews, I typically record the session in two focal lengths, most often

a medium shot and a medium close-up, in case I'll need to edit pieces together later in post.

Most executives understand what you're trying to do, and do their best to make the recording natural, but typically the best you'll be able to do is get somewhat close to "natural." When I see I've reached the point where the executive or his "gang" is getting antsy, and I've gotten a decent read, I'll say something like, "Okay, I think we've got it. I'd like to do one more just as insurance, in case we've had a glitch somewhere. Don't worry about trying to get it right this time. Just let this one roll off your tongue however it comes out, and we'll call it a day." Often times that last read, having taken all the pressure off the executive, will be the best one.

Finally, for executives, have your videographer spend a little extra time on lighting and set up to be sure the executives look as good as possible. Hopefully, you will have an assistant that will help with any light makeup needed to keep the executive from getting "shiny" under the lights, and to keep his shirt, tie or jacket straight. Keep in mind the objective is to get a smooth, natural message, making the executive look as credible and charismatic as you can.

SO . . .

Working with actors and employees is one of the most challenging parts of a producer's or director's job. The time constraints and intrinsic pressures of production work require a steady, confident hand, and sensitivities not only to the feelings of actors and employees on the set, but also the feelings of clients and audience members who will watch the performances and hopefully benefit from its presentation.

Much of the skill a director and producer must have to be successful at these challenges comes from experience and an openness to try new techniques and ways of communicating with people. In short, the directors or producers that are open to growth and new creative possibilities are those who will ultimately be the most successful in the business of corporate media.

8

PRODUCTION

"Action!"

In This Chapter

I mentioned earlier that on my first day at the production facility in a large company my boss sat me down and said he wanted to talk to me about POTS (Proposal, Outline, Treatment, Script). Another memorable comment he made was that if the full production process were laid out on a continuum, the shoot would be a very short part of the overall process. He was right, of course. But what I learned over time was that it is also a very critical part.

All the elements planned for in preproduction are brought together in that short, but intense period of recording: people, equipment, locations—all of which can cost a good deal of money—must be coordinated almost flawlessly to achieve success. I say "almost" because I've yet to direct a shoot on which at least a few things didn't go wrong.

BREAKOUT 8.1 "KNOWING WHAT WORKS: THE KEY TO CREATIVE 'INSTINCT'"

You've just watched playback on a shot involving a host addressing the camera as he walks through an office area. The shot included a fairly long dolly move, beginning with a tricky tilt up and rack focus from a computer screen. The crew and client are standing around the monitor with you.

The videographer speaks up first. "You'll never get the move any better," he says. "It was right on the money."

The audio recordist follows with, "Sound was perfect. No rustle, good level. Crystal clear."

The AD turns to you offering a congratulatory smile and thumbs up.

And finally, the client chimes in with, "Looked really great to me. Boy, this actor is good."

Does this sound like music to any director's ears?

Sure it does. But in this case there's one little problem. You weren't sold on the performance. You felt it was a little too stiff and formal to come off credibly. It didn't have the warm, conversational quality you've decided is an important part of making this host character believable. Adding to your discomfort is the fact that this was take nine, you're an hour behind schedule, and the client has been pacing nervously since take five.

So, here's your dilemma: Do you buy the scene and move on in hopes of making up some time and getting back on schedule? Or do

(continued)

(*continued*)

you get farther behind, irritate everyone (including your tiring actor) and call for take ten?

As you think about your answer, consider the fact that this is a common situation in the world of the corporate media director, and it gives rise to two very interesting questions.

First, who's right? If everyone else watching the scene thinks the performance was great, why argue about it? Your videographer is a well-seasoned pro. Your sound person has been around forever. And the client? Heck, he's paying the bill! The majority voice should be accurate, then, right? So, why not just call it a buy and move on?

Second, what exactly is this performance you want, anyway? And how should it be judged? What is the manifestation of the "warm and conversational quality" you're after? Is it smooth? Informal? Casual? Chatty? Let's assume we define it as smooth. Does smooth, then, manifest itself in the same way for you as another director? Is there a chance one of your peers might watch this same shot and actually say it's *too* smooth? *Too* causal? It needs more "authority," "presence," more "formality?" The answer, of course, is yes, and I'm sure you get my drift. Judging any shot—or, for that matter, any aspect of a creative work—can seem like a confusing, and at times, very frustrating *paradox*. A "good" piece of work in one director's eyes might be judged as "poor" by another. And who's to say which one is right?

Though the question may *seem* paradoxical, the answer is actually very simple.

A small percentage of any group of directors will have a subtle but invaluable aesthetic sense that I call **knowing what works**; three simple words, but in the business of creating good media they define the "instinct" that makes the best writers, producers, and directors stand out from their peers. Why? Because knowing what works gives these creative people the ability to view a performance, script, or complete program and experience a very accurate gut-feel for how good it *really* is.

So where does this "knowing what works" instinct come from? Again, the answer is not rocket science, but it is important. Knowing what works comes from an ability to view your work, not just through your own creative eyes, but rather through the eyes of your audience. Audience—there it is, that all-important word so many writers, directors and producers don't quite understand.

Those who do, know that the best of them, both in Hollywood and the corporate boardrooms across America, are acutely tuned and in perfect creative sync with the tastes and preferences of their audiences. When they accept or reject a scene, they are not just standing in front of a monitor surrounded by crew and clients, they are also sitting in a conference room or theater, weeks or months in the future, as the final product they've created plays on a screen. And through the combination of these present and future aesthetic perspectives, they gain an immediate, very accurate gut-instinct of **what works**.

Which brings us back to that initial question.

If it's you in front of that monitor, do you buy the scene and move on, or go for take ten? Once again, the answer is simple—simple to state, that is. If, as you sit with the audience in that theater or conference room in your future, what you've just witnessed rings completely true and comfortable, buy it and move on.

If it doesn't?

Grit your teeth, take a deep breath, and say, "Sorry, folks. First positions, please."

THE DIRECTOR'S ROLE

Many of the "issues" that arise on a shoot can, and should be, dealt with by the AD and other crew members. Some of the most important things a director deals with are:

- Execution
- Command
- Critical judgments.

As the director you are the guide, the supervisor and the critic who will judge the actors' or employees' performances. As the guide you set the pace of the shoot and move it forward towards a successful, cost-effective and hopefully "on-time" completion. That may mean detours at some points, dropping shots or even complete scenes, talking with clients and company personnel, overcoming any number of obstacles and generally creating a sense of confidence that the crew will find comfortable and reassuring.

A director who does not have command or does not guide a shoot effectively will leave the crew hesitant and anxious. I knew a director who operated by the seat of his pants and often had to put up with chaotic mishaps and all manner of problems and delays. He did manage to get material shot, but it was only with a great deal of help from the crews he hired. The videographer would often be in charge of working out blocking and lighting on the spot. He would also have to give directions to actors, asking them to hit marks, turn certain ways or walk slower or faster. The crew would scramble to get lighting set ups in place and often "run" to the next scene to try to keep the shoot on schedule. Meanwhile the AD would run interference for the director with the client and company employees.

As I said, he did get material shot and, for the most part, he managed to get by on this type of work ethic, but he got very little respect from the crews he worked with and often the actors or employees. In my mind, without the respect of the people he works with, a director is failing at one of the most important aspects of the job. In addition, the work he produced could have been of a much better quality had he taken the time to prepare and schedule properly.

BREAKOUT 8.2 "HANDS-ON AND HANDS-OFF DIRECTORS"

I've worked with "hands-on" directors who micromanage virtually every element of their projects. I've also worked with "hands-off" directors who place virtually all of their focus on the actors' performances and let the videographer, sound, grips, gaffers, PAs and others

do the rest—for instance, select angles and focal lengths, determine the lighting, and even lay out basic blocking.

I'm the hands-on type, but I try not to be obnoxious about it. My reasoning comes down to a single word: Accountability. On a shoot I'm directing, I am the one who will very soon attend an approval meeting in which the client, and possibly a troop of other managers and executives, will gather. If during that meeting a particular shot, wardrobe choice, sound issue or blocking are disappointing to these clients, I will be the person accountable to those clients and (probably also sitting in on the meeting) the producer. That's a big responsibility from both a creative and financial perspective. In some cases it may involve thousands of dollars, critical timelines and company or departmental reputations. It's a responsibility that I take very seriously.

It is because of this level of accountability that I have no qualms asking the videographer or, for that matter, any crew member to change some element of any shot. Since I'm going to be the only one held accountable, I feel it's imperative that I trust my gut and make sure that what I get on the screen is a reflection of my tastes, opinions, desires and logic.

The same holds true for postproduction. Significant creative decisions are made in the edit suite. The editor will have his tastes and opinions, as will the sound engineer, and I will always be open to them. But in the end, I will always make the decisions for better or worse.

PREP: THE KEY

So what is the key ingredient? The preparation we've been discussing in earlier chapters: the careful thought and attention to detail in preproduction; the visualization and consideration of what it takes to get certain shots; the empathy that helps a director recognize good performances by his actors; careful scheduling, and the sense of confidence this type of preparation produces. It's this confidence that allows the director to make calm, admirable,

effective decisions, and earn the respect of all crew members as well as actors and employees.

REAL WORLD VERSUS ABSOLUTE PERFECTION

As much as we writers, producers and directors talk about the challenges of achieving excellence in all phases of our work, the truth is that absolute perfection is often an elusive and difficult commodity to come by—especially in media production. I've experienced countless situations where I've had to settle for something less than 100 percent perfection, and all producers and directors fight this battle continually. So what is the relationship between talk of perfection on the pages of a book like this and the reality of judging recorded performances under enormous pressure in the field?

I call it just what it is: "*real world* perfection."

Not long ago I produced a program that offers a good example. It was a semi-dramatic show on the terrible effects of alcohol addiction. I had done extensive preparation on the production, and hired what I felt were excellent actors and crew. I was hit with a big surprise, however, on day one of the shoot. The person I had cast in the lead role was not up to the task. She had obviously not studied her lines, and she was simply not nearly as comfortable and convincing in the role as I had thought she would be. As I thought back to the auditions, I felt perhaps I had been more taken by her look and a kind of brooding personality she seemed to exhibit than her performance. She was very thin and, although somewhat attractive, she also looked weathered as if years of alcohol addiction had taken its toll on her. The reads she had done seemed very convincing to me and based on those criteria, I had chosen her for the role. Now, however, on the shoot, her performance felt stilted and "overbaked." My first thought was to work with her. At one point shortly after we had begun, I asked the crew to take five and I called her aside. We discussed the role and I encouraged her to take whatever time she needed to get comfortable in the character and, when she was ready, to "take it down a notch of two."

It didn't work. I was placed in a position no director wants to experience. My lead actor was not working out and, as a result of her performance,

the program would appear corny and overbaked. The client (who thankfully was not on the shoot) would cringe when she saw the edited scenes.

I decided that instead of panicking, I would take some time by myself and consider options. I gave the crew an early lunch and thought it over. I realized much of her unconvincing performance showed in her facial expressions and gestures. Her voice alone wasn't great, but when it wasn't matched with her facial expressions, and when it was edited to eliminate some words and phrases, I felt that with the help of a good editor we could make it work. And I knew that, in postproduction, there were ways I could significantly reduce her time on camera. I could also use the strong performances of the other actors to drive home the believability of the scenes.

In short, it worked well, but not to *perfection*. The client didn't notice that in post we had cut around the lead actress to a large degree. And he was very pleased with the end result, as was I. So that was one program that, under the circumstances, ended up not being "perfect," but given the conditions and the options available at the time, what I thought of as "real world perfection."

This is just one of many situations that come up in production. The point, of course, is that as directors we all want the perfection of wonderful camera shots, Academy Award-winning actors, gorgeous lighting and crystal-clear sound, but the reality is many times this is not possible. How we deal with that lack of perfection—the judgments and decisions we make and the results we produce—are powerful measures of our creative professionalism.

QUICK TIPS

Though I have not covered the mechanics of production in this book, I have talked about knowing what works and some ways to achieve it. The following are a few brief production tips that support that aim.

Shoot to Cut on Action

I worked with an intern who was directing a PSA that offered help to teen runways. One scene involved a mysterious man standing under a streetlight

at night. He was to open out his jacket and inside we would see superimposed titles (offering a helpline) move up and out of an inside pocket.

We had set up a single streetlight in black limbo in one corner of our studio. The talent was an employee. His action was simply to open his jacket, revealing the pocket inside, and holding the jacket open as (later in post) the titles emerged. The image would then freeze and a voice-over narrator would tell viewers how critical it was that they contribute.

When we were nearly set up, I noticed the intern had brought in a ladder. I asked how she planned to cover the scene. "It's pretty simple," she said. "I'll shoot a wide shot from a high angle so we'll be looking down on the man under the light. He'll just stand there and on cue, open out his jacket. I'll also get an eye-level medium shot."

"Great," I said. "The high angle sounds perfect. Then what?"

"When we have that shot, we'll bring the camera down to just below eye level and I'll shoot a close-up of his open jacket. In post, we'll freeze it and super the titles."

"Will the jacket already be open when you shoot the close-up?" I asked.

She started to say yes, but then realized what I was getting at and had a second thought. "Ah . . . no. Actually, we'll have him go through the motion of opening it so we can cut on the action in post."

"Excellent," I said. "Let's do it."

She had remembered that when the footage arrived in post, the editor would be looking for action on both shots—the high wide angle and the low medium close-up. That would allow him to make the edit from the high to the low angle in the "*middle*" of the action of the jacket being opened, thereby making the edit all but invisible. Had she shot the low angle as a still shot with the jacket already opened, the editor would have had to wait for the action in the high angle to *come to a stop* and then cut to the low angle, also still, with the jacket open. This would mean he'd be cutting together *two still shots*—which would accentuate and call attention to the edit.

This is an important bit of craftsmanship to remember. On virtually any two shots that will cut directly together, if there is motion involved, the director should be sure to record motion on the tail end of the outgoing

shot and on the front end of the incoming shot. This will allow the editor to create good clean edits that, assuming continuity is intact and the shots are not jump cuts, are virtually invisible.

Shoot for a Variety of Coverage

Along with the idea of shooting to cut on action, whenever possible a director should also shoot for variety. Angles and focal lengths should vary in order to keep visual interest on the screen. A series of, say, wide shots with no medium shots or close-ups to break up the action can become visually monotonous and tend to "hypnotize" the audience. A variety of shots, on the other hand, will keep the viewers' eyes moving, discovering and interpreting what is being presented on the screen—in other words, it will keep them involved.

Consider Shooting Interviews with a Racked Out Background

Camera placement can have a powerful effect on shots of interviewees. Though it's not always advisable, most times I try to place the camera a good distance, perhaps 20 feet or more, away from the subject. I also try to combine this with a location that has a good deal of depth behind the subject, again, perhaps 20–30 feet—or more. With these kinds of distances, you will have to zoom in prior to shooting the interviewee to get a medium close-up and that will have the effect of "crushing" or racking out the background and foreground. This will make the subject stand out in the frame, creating an image that, assuming the light is good, will be very attractive. The out-of-focus background will also provide a nice soft background for the interviewee's upper-body image to appear in. In addition, sometimes out-of-focus foreground images, perhaps the edge of a plant or a book can also enhance the shot.

This isn't always the best choice, for instance when background items must be seen, and perhaps be readable. But in many cases the longer shot works very well.

It's a good idea when scouting, however, to be cautious of backgrounds that may be too "hot" or bright. A "blown-out" background will require additional lighting to "pump up" the foreground image of the subject. And most times this makes the subject *appear* to be lit—not a very nice look.

On the other hand, a camera placed very close to the subject will necessitate a wide angle to get a medium close-up, possibly creating a bit of lens distortion. Of course, there may be times when this type of look is the objective.

Sound Can Make or Break You

I directed a United Way program designed to solicit contributions from employees of a very large company. The subject was substance abuse and the story involved an addicted mother and her son. Much of the dramatic material was shot in my home. All went very well (I thought) until I got to postproduction and found that the audio on two key scenes—that had been shot in my kitchen—were "boomy" (they had a slight, but disturbing echo). The problem had come about because the audio person on the shoot had not done his job correctly. He'd heard the boomy audio in his headphones as it was being recorded, but never called my attention to the problem. As the director, I, too, was at fault. I normally watched and listened to playback of each take, but on this shoot, we were behind schedule and since the actors' performances had been so convincing, I simply looked at the camera and sound person and got thumbs up telling me that all was good.

We ended up having to do dialogue replacement on these shots. This meant placing newly recorded audio over the video, matching the actor's lip action. It turned out to be a nightmare. Talent had to be re-scheduled for another day and as she watched playback on a monitor in a sound booth, she had to try to say the lines convincingly, matching the lip movements of the scene shot in my house.

What I can say about that incident and other sound problems I've run into, is this: If sound issues are overlooked in the heat of production, they can severely damage your program, which you will discover *after* the shoot

in post, when it's too late. My suggestion is this: regardless of your schedule, be sure to record quality sound and consider it equally as important as recording quality images. Take it from me, if you don't, it's not a matter of if, but rather *when* that audio will come back to bite you!

COLLABORATING WITH THE CREW

It has often been said that film and video production is a collaborative effort. In many respects this is true. The work of the crew has a major impact on how well the shoot goes and the end results. The videographer will pan, tilt, focus and zoom, all of which will provide the attractive shots the director is after. The grips and gaffers will keep the shoot moving and provide lighting and support for the videographer's work. The AD and production assistants will deal with the client's wishes, actors, paperwork, employees and executives' needs.

In many cases, these are the utilitarian aspects of a production. The creative aspects, however, are a different animal. The director is hired primarily for his creative talent and ability to work with professionals to get acceptable, editable segments and credible performances. This means that the director should make most of the creative decisions independently. The word "collaborative" does not refer to a director having a democratic-type decision-making meeting with crew to call a performance a buy or go for the next take.

This is not to say that crew members may not have valid suggestions. In fact many times they do. But whether or not to incorporate those suggestions, and to what degree, are still judgments that will be made by the director. I have had crew members make very good suggestions and I've sometimes used them. Most times these come from the videographer or the AD, since these two positions are closest to the director's work. And when they're not appropriate, I often say something like, "Nice idea. But I'm not sure it would cut in post. Let me get the coverage I know I need, and then if there's time, we'll see." In many cases, there is not enough extra time to get a suggested shot. But if there is, it doesn't hurt to give it a try. It could be excellent.

BREAKOUT 8.3 "'DISCUSSING' THE PROPER ANGLE"

I directed an interesting video sequence a number of years ago on the subject of distance learning. One scene called for two actors at what appeared to be different locations having a teleconference—a conversation via cameras and televisions on a digital network. This meant several shots would be angles establishing that each actor was being projected on a TV screen, but I also decided to shoot several angles that showed each actor as if we were in the room with them.

The videographer I was working with was new to me and somewhat new to the craft. I was aware of his background, but a little surprised to find that he was intent on letting me know that he was a better judge than me of the proper angles and focal lengths. This became apparent as we prepared for a scene, when I asked him to place the camera lower than eye level on the actor to be recorded.

"You want a low angle?" he asked with a concerned tone.

"Right," I said, "But not much. Just so we're looking up at him slightly," I replied.

"You don't want to do that," he said.

"Why not?"

"It'll be too dramatic."

Although a low angle can create a dramatic sense in many cases, in this one I knew it would just provide a little more visual interest and variation from the standard back-and-forth angles we had been recording. "No," I said, "It's just slightly low and in his case it'll be fine."

"Here. Let me show it to you at eye level," he said, decisively, as he started to adjust the tripod legs to keep the camera at a higher level.

"No, John," I replied, "We really don't have time right now. Just frame it up a little low and we'll be fine."

He did as I asked, but shook his head, making it obvious he wasn't happy with my decision. Several weeks later when the show had been cut and approved by the client, I ran into him prepping for another shoot. "How did that scene with the low angle turn out?" he asked.

"Great," I said. "It cut very nicely and it gave just a little more visual interest."

He said nothing, but shrugged and walked away shaking his head just as he had on the day we shot it.

There are two lessons in this story. The first is for the director. He should be prepared, confident and decisive about shot selection and all visual aspects of the project. Second, a videographer should be prepared to offer input to the director, but only if the director wants it, and never in a way that appears to suggest he is the final authority.

9

POSTPRODUCTION

*"Does it **all** happen in post?"*
"Not all, but a bunch!"

In This Chapter

The Editor's Role
From Pieces to a Whole
Fix It in Post?
Recognizing Performance Credibility
Clients and Producers: Pick Your Battles with Great Care
Cuts Only or "the Works"?

Two positions in the overall production process are close enough in function to be considered critically supportive partners of the director: first is the videographer and second is the editor. The videographer helps the director create live recorded camera shots and the editor fits those shots together into cohesive, "naturally" flowing scenes that make up a program.

THE EDITOR'S ROLE

It's obvious that the editor's role is a crucial one, but some media professionals (mostly editors, I believe) feel theirs is the paramount role. I've heard

the phrase, "It all happens in the edit bay," quite a few times over the years, and, at the risk of seeming defensive or territorial, I can assure you it's an overstatement. I don't mean to dismiss the critical role the editor plays, I'll be the first to say that a good editor can be a great creative force in making a program memorable and a bad editor can ruin one. I have learned from, and been helped greatly by editors, but the simple fact is it does not all happen in the edit bay.

BREAKOUT 9.1 "AN EDITOR'S CONUNDRUM"

I once produced a public service announcement (PSA) designed to encourage donations for a children's charitable organization. It was narrated by an on-camera speaker who was a celebrity baseball player.

I had recorded two types of coverage of the speaker. One was a slow dolly move from a wide shot to a medium close-up. It ended just at the point where the speaker would go into voice-over as the address for the organization appeared full screen. The other coverage consisted of two shots. One was a lock-off (still camera) medium shot in which the speaker went through the entire read. Complementing this was a close-up of the same lines that could be cut in at any time for a more intimate, or perhaps dynamic, feel as he made the case for giving to the organization.

I viewed all the footage several times before handing the material to the editor. Although I liked the lock-off and close-up, in the end I preferred the dolly in to the medium close-up as the speaker reached what I felt was a powerful close. His words at that point were, "They're frightened and alone, and they're depending on us for help." Following this would be an effect that would take us to a graphic screen with instructions for giving.

I left the editor instructions, and spent the next day in off-site meetings. When I returned to have a look at the program, the editor had decided he liked the lock-off and close-up better than what I'd asked for, and he had cut the piece accordingly.

(continued)

(*continued*)

I am not opposed to editorial input. There have been many occasions when an editor's creative ideas have improved my shows. What I was not happy about, however, was the fact that he had not created a version to my liking so we could compare the two. Also, when I brought this up and told him I'd like to see a second version per my instructions, he rubbed salt in the wound when he said, "Why do that, Ray? This looks great."

I agreed that his work looked very nice, but reiterated that I wanted to see a version with the dolly shot. He shrugged and in an off-handed tone said, "Sure . . . Whatever you want, boss."

The interesting thing is that in the end I agreed that his cut was the better choice, and that's how we did the final edit, but after a second conversation with him in which he told me (you guessed it) "It all happens in the edit bay," I paid him and crossed him off my list for future work.

FROM PIECES TO A WHOLE

The editor is given a series of recorded shots, sounds and graphic elements. He or she is tasked with assembling those segments in the most fluid, dynamic and effective way possible. Prior to this, the director is given a script and is tasked with: auditioning and casting actors; scouting and confirming locations; blocking camera moves and angles to get the most effective shots; directing actors; overcoming the many obstacles that regularly arise during production; directing graphic artists and finding the right musical selections; leading a crew of professionals through these obstacles; and handling clients and producers in a way that makes them feel comfortable and secure that the program is in good hands and will come to a successful end.

You can probably imagine that the director and the editor might experience conflicting opinions on how parts of the program should be edited. In most cases, this is a healthy process that, if treated with humility and openness on both sides, will result in a high-quality end product.

FIX IT IN POST?

There is also the old saying, "fix it in post." You probably know that this means the director has ended up with some sort of compromise or problem in production, hoping to fix it later in editing. One example might be settling for a shot in which, say, the boom mic. dropped into the shot during a take. Assuming the schedule is tight and the director feels he cannot go for another take, he might feel that "fixing it in post" is the best choice.

Not too many years ago, this was considered a cop-out by a director. Why? It often led to a disaster because the program could not be fixed well enough to meet the client's or producer's standards. Directors learned that many times, the process of fixing one problem in post led to another. As an example, to fix the appearance of the boom mic. in a shot, the edit might have to use a digital zoom to pull the shot forward, and this would degrade the image quality—perhaps to a noticeable amount. These days, however, though I cringe to say it, technology has come so far that a "fix it in post" decision can usually be effective, and therefore perfectly acceptable. I always try to get the very best I can in the field or the studio, but circumstances can sometimes dictate a "fix it in post" decision. When this is the case, I feel much more comfortable with the idea these days than I did 20 years ago.

One example that I faced was the previously mentioned lead actor who simply could not match up to the abilities of the other actors on the show. Yes, I had cast him, and admittedly it was a mistake, but as I mentioned, when I realized the difficulty we would have with his material, I shot extra coverage; combined with a talented editor, this allowed us to "cut around" the actor enough in post to make the show successful. Many times when she was delivering lines, we cut to reaction shots of the other actors, over-the-shoulder shots in which her lips couldn't be seen, or B-roll. In the end, I knew it would never occur to the audience that we had done this. And the actor's audio, when we weren't seeing her face, "sold" the performance.

RECOGNIZING PERFORMANCE CREDIBILITY

Another aspect of postproduction that can cause a director heartburn, is an editor who is not in sync with the director's opinion of a good performance. Quite a few years ago, I brought material to an editor and, as we were

viewing it together, what turned out to be a big problem surfaced. The editor was delighted with the dialogue of all the actors—in fact too much so. Personally, I was not completely happy with one actor's performance, and I could see that in the final analysis this could hurt the show's credibility. I also knew that by eliminating parts of a few scenes, we could cut the show keeping his appearances to a minimum.

When I told the editor I had decided to eliminate the material in question, he thought I was making a big mistake. "You're kidding!" he said.

"No'" I said. "His performance isn't that convincing in those scenes."

"But it's good, solid dialogue!" he said, "It's a shame to waste it!"

"I just think the show will be a lot more credible if we keep him to a minimum in those scenes."

The editor wasn't happy, but he did cut it as I had asked and, in the end, the show played fine.

My suggestion to new directors, or those having trouble dealing with these kinds of issues, is to first view the material *objectively imagining you are the client or an audience member*. Then ask yourself a few questions:

- Will it ring true?
- Will it look and sound "real"?
- Will it support the objectives originally set out for the show?

Based on the answers to these questions, go with your gut feelings when working with editors, producers and others involved in the show. But if there is disagreement, handle it in a professional and respectful way.

CLIENTS AND PRODUCERS: PICK YOUR BATTLES WITH GREAT CARE

Remember that you will not win all battles. There will be times when a producer or client is unflinching in his call for changes and you'll simply have to live with that. Some directors can get defensive when put in this situation. Their opinion is that they are the most qualified to make creative decisions, and they're not inclined to abandon their principles. My suggestion to these folks is to remember that, although we all want to be proud

of our shows and do the best possible work, in the end (remember—the real world) it's a training or marketing project, not a major, dramatic feature film or documentary. And becoming entrenched in "principles" can create a professional image that no freelancer wants—that of a "difficult," "Hollywood" or "artsy" director who is unwilling to compromise. He will be viewed as over the top creatively and, to put it frankly, a pain in the rear to deal with. Translation? A director (or writer) who is overlooked when future jobs come up.

BREAKOUT 9.2 "THE DOOMED DIRECTOR"

A good friend of mine who was an accomplished corporate director, ended up out of a job because of some poor choices on an executive production.

He had been given a project aimed at preparing employees for fast-paced technical changes that were rapidly reshaping the company and the industry. The program included an interview with the president of the corporation we worked for—a very large telecommunication organization. My friend set up and shot an interview with the president in the "ivory tower."

When he brought the footage back and began working with an editor, he told me that he was going to be sure the interview sequence was cut to show that the president, a man from the south with a pronounced drawl, was not just a figure head but a real person. I wasn't exactly sure what that meant, but a few days later I found out.

He had edited the sequence keeping in a few "flubs" made by the executive. In one case, the president had lost his train of thought and had to ask an assistant to remind him what to say next. In another, he couldn't find the right words and stuttered and stammered for about 5 seconds (which can be an eternity on the screen).

I knew my friend had been unhappy at his job for some time, and very critical of our immediate supervisory staff. I suspected that his

(continued)

(continued)

hidden agenda was a kind of passive aggressive way to "get even" with them for what he felt was their mishandling of our department. I could see a disaster coming and I told him that frankly. "Think about it," I said, "To you it may seem like you're showing the president as a real person, but to the rest of the executives in the company, you'll be presenting him as a kind of bumbling fool. *Don't do it!*"

Well, he didn't take my advice. He cut the sequence as he had planned and because our immediate boss was out of town, my friend showed the program to a group of executives who were stunned by what they saw.

The program was immediately halted until my boss got back into town. Then a series of meetings were held which culminated with my friend's "departure" from the company. He left still feeling he had "done the right thing," but my opinion was, and still is, he blew it.

As far as I am concerned, he could have simply left the company if he felt the supervisory staff were incompetent. He did not have to do it by embarrassing the head of the corporation and burning his bridges.

CUTS ONLY OR "THE WORKS"?

There is much to be said about the power of simplicity. But when applied to today's corporate media world, it can be a tricky word. For instance, what does simplicity mean when applied to, say, a program for a large company highlighting their new product release? Simplicity could mean producing or directing a program with a simple "cuts only" style that relies mostly on dynamic images and does not incorporate much in the way of visual effects. The effects I'm referring to might include "fancy" transition edits, of which there are many, and/or picture manipulation such as coloration, slow motion, strobing, split screens or any number of other special effects.

For the most part, I am a simplicity person. I try to make the images and graphics I have developed display the qualities that keep an audience engaged. That means finding interesting angles, trying to achieve the best

lighting (when it is appropriate), often keeping the camera in motion, and, of course, getting the best performances out of the best actors I can cast. By the way, the idea of simple, powerful performances hinges not only on the camera and lighting, but also depends, as I've mentioned, on the writing— in other words, a script that is credible, natural, accurate and creatively engaging. On the whole, I try to achieve quality programs by applying these elements; however, as I said, the word simplicity can be tricky.

I recall a program a director friend of mine once did that was meant to serve as an "on-ramp" to the "information super highway." I suppose I'm dating myself with that statement, since this was one of the early monikers given to the Internet. The friend did a very nice job of visually presenting images that suggested the fast-moving, electronically charged world of cyberspace. He had a young energetic host that "popped" in and out of an ultra-futuristic set and his program included segments that flashed, swept in and exploded in high-tech sequences that were anything but simple.

To be perfectly honest, at the time I became a bit envious. It looked great, and it occurred to me that maybe I was behind the times because I didn't typically adorn my shows with these kinds of "fancy" effects. Then again, I reasoned that at the time I hadn't yet done any shows specifically focused on subjects like the Internet. And therein, I realized, lay the answer to my dilemma. For the most part, the program design and the objectives should dictate the level of "complexity" or "flash." Shows that are based primarily on actors' interactions might not be mutually exclusive of special effects, but would typically require more cuts and less flash. Shows, on the other hand, that contained elements of modern technology or futuristic ideas should certainly be more "slick."

The trick is to figure out the type of program you're writing, producing or directing by development of the Program Needs Analysis. Based on this clarity of design, when it comes time to prep, shoot and edit the program, significant visual planning should take place. Effects require thinking through how they will appear on screen, what exactly they will do or show and how they will transition between scenes. If actors are to appear in these types of scenes there is a good chance green screen Chroma key work will be involved, which most often involves studio time, additional planning and special lighting.

You may notice that I said the type or degree of "flash" should be determined "For the most part" by the type of program it will be. That's because there is another facet to this decision—the client, and his desires. Many times clients will be in favor of special effects and flash for the simple reason that it makes the show look "cool"; it's more like what they see on TV at home and they want a slick look and feel to represent their company, department or products. This is a valid opinion, and when it's the case, assuming they are willing to pay for the extra time and resources, you would be wise to provide what they want.

10

APPROVALS AND CLIENT MEETINGS

In This Chapter

Return of the PNA
Dealing with Client Changes
Leave Your Ego at the Door

Talk of client opinions brings up the topic of just how to handle clients—and producers. Both of these individuals are your bosses on corporate shoots. The producer is typically a direct liaison between you and the client, and he is also your supervisor. Aside from producing successful programs, he's intent on keeping his budget in line and making his department "shine" for his boss. The client, on the other hand, is not your direct boss, but what you might call a very "influential collaborator" regarding the look and feel of the program.

This type of reporting usually works just fine, but it demands that writers and directors show a healthy respect for their producers and clients. It is also critical to understand that at producer and client levels, politics, money and pride are often influential factors in their thinking and decision-making—that's the nature of the beast. As a writer or director, you should accept this fact of life and make it work for you. Doing so will leave your clients and producers very happy, and, provided your work is of professional quality, it will virtually guarantee callbacks for future projects.

I have worked with many writers, producers and directors and I've found that the best rule of thumb is to respect their abilities and positions. This is a general rule that, of course, is applicable to any job, and it's based on the simple fact that the producer is more likely to call you in for more work in the future if he is comfortable with you and feels you have respect for him.

RETURN OF THE PNA

When it comes to approvals, three letters come immediately to mind—PNA, i.e. the Program Needs Analysis developed at the show's inception. You will recall that one of the key segments of the PNA was Objectives. If you developed them carefully, writing specific expectations of the program, now will be the time to compare what you and the client decided, and what has come to pass. In other words, having now looked at the final cut, do you feel the show does what you both had intended?

Let's look back at some of the key parts of our example PNA from Chapter 3.

As I explained previously, the Problem may not be evident to many clients, but there is *always* a problem otherwise there would be no need to produce a video. In this case it was:

PROBLEM: Academic and community members are not aware of the long, rich and important history of Oxnard Adult School, including the fact that this year will mark its 75th anniversary.

Will that problem be solved by this program? We can find out in several ways. One is simply to watch the program and discuss whether it clearly conveys the point. You might also gather a room full of typical viewers, show them the program and survey their opinions. Another indicator might be the distribution:

UTILIZATION/DISTRIBUTION: This program will be shown at the WASC reception in the spring of this year. It will most likely be presented via computer projection. It may also be uploaded to the Oxnard Adult School website, and possibly be broadcast on local cable through Time Warner and the Oxnard Government Channel (26). To meet these distribution requirements, various formats may be needed, including standard DVD and MPEG.

A simple verification of the utilization steps that will be undertaken can help answer the question. Are the same distribution plans still in place? If so, that's great, but there's more to it. Assuming it is distributed per the original plan, once it gets into the hands of audience members, will it do what was intended? To find that out, how about a look at those original objectives?

Would reviewing them and comparing them to a viewing of the program give some indication of whether they have been achieved? Absolutely. An assessment of the objectives should be discussed and agreed upon in the client approval meeting, just as they were initially agreed upon at the project inception. A starter for that discussion might go something like this:

"Well, we've seen the program, now let's have a look back at what we agreed it should accomplish. Here were the objectives we decided on in the PNA:

OBJECTIVES: This program will meet both motivational and informational objectives as follows:

Motivational: This program will motivate community members to regard the school in high esteem, value its presence in the community and, in appropriate cases, consider attending or seeking more information on how the school might benefit them.

Informational: Having viewed this program, audience members will be able to:

1. state that Oxnard Adult School has reached its 75th anniversary;
2. state that the value and scope of Oxnard Adult School in the community are both very powerful, though they often go unnoticed;
3. state that Oxnard Adult School has had a long, positive effect on students, enriching their futures and helping to create exciting new opportunities.

As we know, specific, quantifiable results are not normally expected from motivational objectives. Quantifying whether someone truly understands or is motivated is difficult. I think we can assume that if the other more specific objectives are met, the motivational one is assured. So let's look at the other three.

Do we feel that if asked, viewers will be able to state that Oxnard Adult School is 75 years old? It was a topic of discussion in all the interviews, and we had graphics, and of course the titles, that presented it throughout the show. I'd say that's pretty well assured.

Number two said viewers should be able to state that the value and scope of the school in the community is powerful, but often goes unnoticed. Do you think that if asked, viewers would be able to state that? In the program, that idea was discussed frequently and we had interviews and support titles, so I believe that's covered. And finally, number three states that the impact the school has on its students is positive, valuable and helpful to their futures. Do you think viewers got that? All the students interviewed were very complimentary of the school, its curriculum and its teachers."

To be 100 percent positive the show accomplished these objectives, you would have to initiate a group discussion or a survey immediately after a viewing of the show. Sometimes this is the case, most times, however, a discussion with the client and producer is adequate. The important thing is to make sure that the client realizes that those objectives laid out in the very beginning weren't just for show. They were actually guide posts used by the writer, producer and director to bring the show to a successful result.

Finally you may remember that we said another important quality, similar to objectives, was a determination of whether the program was produced with professional quality. Again, this can be discussed and determined by viewing the show in the approval meeting.

DEALING WITH CLIENT CHANGES

When it comes to approvals, never make excuses or place blame. Becoming defensive about changes a client or producer might want will quickly land you out of work and not likely the recipient of many future phone calls. Most Producers are much too busy to deal with disruptive people who feel they are special and take the client's or your comments as an affront to their "elite creative status."

On the other hand, there is no problem with professionally voicing your opinions based on your background and experience. The trick is to do it the right (tactful) way, and let the client or producer know that, although you have certain opinions about the project, you're certainly willing to go with their ideas if need be.

BREAKOUT 10.1 "THE CASE OF THE DEFENSIVE WRITER"

Not many years ago I was placed in an awkward position that involved some very tense moments about a script. I was a writer at the time, asked to fill-in as a producer on a project at the script stage. The writer, who was a friend, had just turned in a first draft of the script—to me. When I sat in my office and read it, I became anxious. I felt the script was not structured well and the narration wasn't conversational or effective from an audience standpoint. In short, it needed changes.

I found myself torn over what to do next. Should I let the writer know that I wanted changes to the script or should I keep my feelings undercover and forward it to the client feeling convinced that it would be sent back to us for revisions.

After giving it a good deal of thought, I decided forwarding a faulty script was not something our department should do. Instead, I met with the writer to see if I could tactfully let her know that I would like to see some changes before we sent the script to the client. My worst fears were realized when we sat down to discuss it and the conversation went something like this:

Basic introductions, then . . .

ME: So, I think it's a good script, but I'm hoping you won't mind making a few changes.

WRITER: What type of changes? You mean like proofing?

(continued)

(continued)

ME: No. Actually I was hoping you could change the structure a bit and see if you can make it a bit more conversational.

WRITER: Conversational? You're kidding!

ME: No, I'm not talking about much, just include some contractions and loosen up some of the word choices and phrases.

WRITER: What? I'll stand by every word in that script and as far as I'm concerned I don't need to change a syllable. Show me what you're talking about . . .

Well, the conversation went off the rails at that point, and the writer remained furious at me for a long time. She felt that because I was given a producer's role for a short time, it had immediately gone to my head. She did make the changes I asked for, but she went to our boss immediately after he arrived back and complained.

As I've looked back on that experience across a span of almost 40 years. I'm not so sure that "doing the right thing" for the department was worth the damaged friendship. Today I'm still unsure, but I believe that because the personal cost was so high, if I had to do it again, I might just disregard the revisions, and send the script to the client.

LEAVE YOUR EGO AT THE DOOR

It's worth mentioning again that some writers and directors come into a production feeling that they have to project a kind of aloof or "Hollywood" image. They feel clients, and in some cases producers, should view them as media elites, "creative auteurs." If you happen to be a new director displaying this kind of ego, there is a very good chance you will develop at best a "difficult" relationship with clients and producers, and at worst no relationship with them. Instead, remember that if you just be yourself and keep in mind that your skill as a writer or director will speak for itself, you will certainly get the respect of peers and those above you on the organizational chart.

11

SIGNING OFF . . . FOR NOW

In This Chapter

A Bit of Parting Advice

Over 40 years ago I made a career decision that changed the course of my personal and professional life. At the time I was a telephone company supervisor with a crew of installers and repair technicians. It was good work and I enjoyed it, but I was also somewhat of a career split personality. At heart I was a writer. I knew that words had enormous power and I loved finding ways to explore that power. I happened to be visually inclined as well.

In the late 1970s an opportunity came my way to write a series of half-hour telecourse scripts for a local PBS TV station, and that sealed the deal. I found that scriptwriting fit perfectly with both my writing and visual aspirations, and my desire to make a living as a writer. But I was still a telephone company supervisor, so most of my time was spent in the field keeping track of my crew.

It was a few years later when another opportunity presented itself—a chance to leave the field as a supervisor and move to the company's video production facility, which, at the time, was a well-funded and professionally outfitted television studio. After some serious soul searching, and discussions with my wife, I made the decision to leave behind my previous role and take on a different type of work and new challenges—those of a full-time scriptwriter.

That journey has been amazing. The creative challenges have been some of the most intense, but personally rewarding, of my life. Graduating from a writer to a director, and eventually a producer, was a period of incredible growth that I wouldn't change for the world.

And in recent years, new challenges: I am honoured to be able to pass on some of what I have learned to new writers, producers and directors, in hopes that I may help guide their careers to be as rich and rewarding as my own.

A BIT OF PARTING ADVICE

If you are one of those newcomers, or perhaps a media professional wanting to move into writing, producing or directing, my advice is very simple:

Write: Write everything you can think of and, whether it's good or bad, just keep writing. Like making shoes, practicing tennis or repairing cars, the more you do it, the more accomplished you will become. Of course, it's also advisable to find writing classes, but most important is simply the act of writing—a lot!

Direct: When you feel you're ready, direct. It may not be some high-end project financed by a company that is paying you, but you can still find (or invent) projects. With the advent of today's ultra-simple, inexpensive and easily obtainable production and editing gear, there is no reason not to direct. And like writing, keep doing it. Strive to improve your skills. Look at what you've done with an objective eye and find ways to improve. Also, search out new ideas and creative ways to express yourself on the screen.

And yes, **produce**. This might not come right away, just as directing may not come until you've become an accomplished writer, but it *will* come if you keep at it and make it your mission to continually challenge yourself by learning new skills and putting them to work on the screen.

So there it is. Now, the last piece of advice—the shortest but most important one of all:

Go for it!

APPENDIX 1
"SCRIPT TO SCHEDULE"
Shoot Breakdown in 4 Steps

The process of breaking a script down to arrive at a basic shooting schedule is best illustrated in 4 steps. To begin we need a script. The following is a 2-page script segment written for a software client.

The iPARAMOUNT logo glides in, it's center rotating. Logo glides out as HOST steps into frame with the ski lift area in BG.

NARRATOR

As complex as the question may sound, the answer is simple—with 360-degree customer relationship management solutions from iPARAMOUNT software.

CUSTOMER TESTIMONIAL #1

An iPARAMOUNT CUSTOMER AT WHISTLER. In an off-the-cuff, news-style interview, he says something like:

(continued)

(continued)

CUSTOMER #1

Managing customer relationships—a must if a company wants to finish first in today's marketplace.

iParamount's software: the only way to do it right.

What it does for customer satisfaction, and ultimately the bottom line, is amazing.

iPARAMOUNT'S PRODUCT LINE—SCREEN IMAGES. Images of icons, charts and graphics float through the frame. Some products at chalet.

NARRATOR (V.O.)

Just how do our customer relationship management solutions give business professionals this competitive edge?

STOCK SHOTS of professional interactions mixed with iPARAMOUNT '98 screens. More title "buttons" glide into the frame per narration: ENGAGE, EMPOWER, EVOLVE.

NARRATOR (V.O.)

Let's start with three simple words: "engage" . . . "empower" . . . and "evolve." Our software solutions help professionals *engage* in lasting and meaningful relationships with their customers. They *empower* employees—*all* employees to take the actions needed—*when* they're needed—whether the employees happen to be sitting at a PC, on an airplane above a foreign country, or on the road with a laptop or personal communicator . . . And they allow companies to *evolve* rapidly and dynamically in a marketplace driven by the simple fact that the rules can change minute to minute.

CUSTOMER TESTIMONIAL #2

At Whistler, another iPARAMOUNT customer speaks off-the-cuff, defining how Pivotal has helped his employees ENGAGE customers. A large transparent TITLE "ENGAGE" SLIDES UP THE SIDE OF THE FRAME as he says something like:

> CUSTOMER #2
> iParamount's Relationship '98 frees sales people up to *really* get to know their customers.
>
> Time they once spent doing paperwork and other unproductive tasks, can be spent one-to-one with the most important people in all our lives—customers.
>
> Makes an enormous difference.

STEP 1

In Step 1, the director lines off all scenes, and assigns each one an individual number. In our example, the scene numbers shown are: 14, 15, 16, 17 and 18:

The iPARAMOUNT logo glides in, it's center rotating. Logo glides out as HOST steps into frame with the ski lift area in BG.

14	NARRATOR

As complex as the question may sound, the answer is simple—with 360-degree customer relationship management solutions from iPARAMOUNT software.

CUSTOMER TESTIMONIAL #1
An iPARAMOUNT CUSTOMER AT WHISTLER. In an off-the-cuff, news-style interview, he says something like:

15	CUSTOMER #1

Managing customer relationships—a must if a company wants to finish first in today's marketplace.

iParamount's software: the only way to do it right.

What it does for customer satisfaction, and ultimately the bottom line, is amazing.

iPARAMOUNT'S PRODUCT LINE—SCREEN IMAGES. Images of icons, charts and graphics float through the frame. Some products at chalet.

16	NARRATOR (V.O.)

Just how do our customer relationship management solutions give business professionals this competitive edge?

Stock shots of professional interactions mixed with iPARAMOUNT '98 screens. More title "buttons" glide into the frame per narration: ENGAGE, EMPOWER, EVOLVE.

| 17 | NARRATOR (V.O.)

Let's start with three simple words: "engage" . . . "empower" . . .

and "evolve." Our software solutions help professionals *engage* in lasting and meaningful relationships with their customers. They *empower* employees—*all* employees to take the actions needed—*when* they're needed—whether the employees happen to be sitting at a PC, on an airplane above a foreign country, or on the road with a laptop or personal communicator . . . And they allow companies to *evolve* rapidly and dynamically in a marketplace driven by the simple fact that the rules can change minute to minute.

CUSTOMER TESTIMONIAL #2

At Whistler, another iPARAMOUNT customer speaks off-the-cuff, defining how Pivotal has helped his employees ENGAGE customers. A large transparent TITLE "ENGAGE" SLIDES UP THE SIDE OF THE FRAME as he says something like:

| 18 | CUSTOMER #2

iParamount's Relationship '98 frees sales people up to *really* get to know their customers.

Time they once spent doing paperwork and other unproductive tasks, can be spent one-to-one with the most important people in all our lives—customers. Makes an enormous difference.

STEP 2

As a second step, the director creates a list of the scene numbers and includes brief descriptions. In this case, graphics and titles are shown with their corresponding scenes, but these will be developed separately by a graphic artist in a studio setting.

Note that the scenes are numbered and listed chronologically, in other words, in SCRIPT ORDER.

SCENE #	DESCRIPTION
14	Host steps into frame near lift area Logo—motion art
15	Customer interview at Whistler
16	Product line images (some at chalet)
17	Stock or B-roll—customer interactions TITLES: ENGAGE, EMPOWER, EVOLVE
18	2nd customer interview—Whistler TITLE: ENGAGE

STEP 3

In Step 3, the director rearranges the scene numbers into a cost-effective SHOOTING ORDER. In this case, Scenes 15 and 18 end up together because they are both customer interviews taking place at the same location, and though they may appear at different places in the script, they can be shot most economically at the same time. This rearrangement process may be based on locations, the talent or equipment involved, day or night scenes, or other criteria.

SCENE #	DESCRIPTION
14	Host steps into frame near lift area (Logo—motion art)
15	Customer interview at Whistler
18	2nd customer interview—Whistler TITLE: ENGAGE
16	Product line images (some at chalet)
17	Stock or B-roll—customer interactions (some at chalet) TITLES: ENGAGE, EMPOWER, EVOLVE

STEP 4

Finally, when all the scenes in the script are listed in an economical SHOOTING ORDER, a very basic shooting schedule can be easily developed. To do this, dates, days, and times are added. It can be revised easily, to add other information or make changes. Note that the graphic and title work to be done is now separated out.

SCENE #	DESCRIPTION	DAY	DATE	TIME
14	Host steps into frame near lift area	Tuesday	7/13	8:00
15	Customer interview at Whistler	Tuesday	7/13	9:30
18	2nd customer interview—Whistler	Tuesday	7/13	11:00
16	Product line images (some at chalet)	Tuesday	7/13	12:30
17	Stock or B-roll—Customer interactions (some at chalet)	Tuesday	7/13	1:30

TITLE: ENGAGE Scn. 18
Logos—in motion, product images

TITLES: ENGAGE, EMPOWER, EVOLVE Scn. 17

All artwork and titles will be created by Mel Servile starting on 7/10

APPENDIX 2
ELEMENTS BREAKDOWN

Below is an abbreviated Elements Breakdown showing the types of items and events an AD, PA or director might note. The Elements Breakdown should reflect *all* elements in the script.

ELEMENTS BREAKDOWN: IPARAMOUNT

TALENT
Host—TBA
Auditions now being
scheduled

LOCATIONS
Whistler—ski lodge
Whistler—gondola, village
and lift areas
Apex studio—(Audio—all V.O.)

MUSIC
In-house library
Director's choice

PROPS
3 PC laptops
2 Surface™ tablets
(iParamount software)

WARDROBE
Cold weather dress, but not ski
attire. Director and client will
make choices on first studio day

STOCK
Larry L. viewing
tapes. Viewing
TBA

SPECIAL
Steadicam—1 day, TBA
Chapman dolly all days—5
Ski package with all accessories

TITLE AND GRAPHIC PRE-BUILDS
Bill Conndi develops all titles,
scheduled to begin 7/10
Mel Servile develops all graphics,
scheduled to begin 7/8

INDEX